Seen From All Sides

Lyric and Everyday Life

SYDNEY LEA

~

Seen From All Sides

Lyric and Everyday Life

GREEN WRITERS PRESSS *Brattleboro, Vermont*

Printed in the United States

10 9 8 7 6 5 4 3 2 1

Green Writers Press is a Vermont-based publisher whose mission is to spread
a message of hope and renewal through the words and images we publish.
Throughout we will adhere to our commitment to preserving and protecting
the natural resources of the earth. To that end, a percentage of our proceeds
will be donated to environmental activist groups. Green Writers Press
gratefully acknowledges support from individual donors, friends, and readers
to help support the environment and our publishing initiative.

Giving Voice to Writers & Artists Who Will Make the World a Better Place
Green Writers Press | West Brattleboro, Vermont
www.greenwriterspress.com

Library of Congress Cataloging-in-Publication Data available upon request.

ISBN: 978-1-7320815-0-5

Cover design by Rachael Peretic

PRINTED ON PAPER WITH PULP THAT COMES FROM FSC-CERTIFIED FORESTS, MANAGED FORESTS
THAT GUARANTEE RESPONSIBLE ENVIRONMENTAL, SOCIAL, AND ECONOMIC PRACTICES.

Contents

~

As For Poets

~

BY GARY SNYDER

As for poets
The Earth Poets
Who write small poems,
Need help from no man.

The Air Poets
Play out the swiftest gales
And sometimes loll in the eddies.
Poem after poem,
Curling back on the same thrust.

At fifty below
Fuel oil won't flow
And propane stays in the tank.
Fire Poets
Burn at absolute zero
Fossil love pumped backup

The first
Water Poet
Stayed down six years.
He was covered with seaweed.
The life in his poem
Left millions of tiny
Different tracks
Criss-crossing through the mud.

With the Sun and Moon
In his belly,
The Space Poet
Sleeps.
No end to the sky-
But his poems,
Like wild geese,
Fly off the edge.

A Mind Poet
Stays in the house.
The house is empty
And it has no walls.
The poem
Is seen from all sides,
Everywhere,
At once.

Seen From All Sides

Lyric and Everyday Life

Accepting My Appointment as Vermont Poet Laureate

~

I WANT TO START THIS COMMENTARY with some modesty, dismissing the notion, for example, that the opinions of poets are brighter than other opinions, and particularly that poets are more "sensitive." I've known barbers, loggers, and waitresses more sensitive to those around them than many poets. If poets do possess an enhanced sensitivity, it is surely only to language.

I have always hoped that my own words might speak to and sometimes *for* people whose command of them is less developed than mine. Yet even my poet's claim to eloquence can collapse before me. I don't want to strike an anti-intellectual pose here, because I have greatly benefited from scholarly intellects, nor some phony pose, either, as poet of the people. Yet I'll insist that if those with fancy educations like mine have no exclusive claim to brains, still less do they have one to lyric expression. Certain yarns and poems have had the profoundest influence on my view of the world. I heard most of these early

on, from a cherished group of northern New England men and women with scanty formal education; but those testimonies have stayed with me at least as vividly as those of literary lions who sleep in more renowned graves.

I have learned, too, in large part by association with my dear introducer Mary Leahy of Central Vermont Adult Basic Education, that a sophisticated demeanor is no indication of a deeper humanity than that of many who struggle with the daunting challenges of illiteracy or sub-literacy. The accomplishments of such people make my own seem minuscule; they humble me.

But a little humility never hurt anyone. I know that in this poetry-rich state, there are people who have as good a claim to my new distinction as I do. I'm conscious too of the mastery that precedes me in the work and person of outgoing laureate Ruth Stone. Self-congratulation would erect barriers between my work and fabulously rich relationships and narratives, available from those fellow poets, yes, but also from many another citizen. With that in mind, I mean during my tenure to visit as many of Vermont's town libraries as may welcome me. I'm a long-time trustee of my own town's library, and so understand the centrality of these institutions to community life. I'll make my visits, though, not to spread wisdom but to garner it.

"Hyla Brook," one of my favorite poems by Vermont's first poet laureate, Robert Frost, celebrates a brook so small that it's "A brook to none but who remember long." With that little stream, he says, things are "other far/

4

Than with brooks taken otherwise in song." The poet concludes, however, that "We love the things we love *for what they are.*"

Like Frost I am no native, but like him too I do love our tiny state. I love Vermont for what *it* is: an enclave of civility amid the virulence of our current national life; a cauldron of inventiveness when many of us seem stuck in our tracks; a repository of humor at a time when Americans appear addicted to grimness; and—as the response to the dreadful storm Irene demonstrated—a context for collaboration at a moment when, as one of my dear old native friends puts it, "people sometimes forget how to neighbor."

Let us remember the imperative to neighborliness. Let us remember, in the words of another great poet, W.H. Auden, that "We must love one another or die."

What Will Suffice?

~

I WAS NOT A BOOKISH BOY. My uncle's farm was, metaphorically, my primer. In it, I could look up, say, how crows specifically communicated, as in "Danger!" Or more vehemently: "*Great* danger! A man with a gun!" As a father myself, I now remember with some horror that from my ninth birthday on, my own father set me loose as the would-be man with gun; I carried my single-shot .22 wherever I went among those old woods and fields.

Father and uncle had one rule: shoot nothing you won't eat. But rather than shooting less, I ate more. I know the taste of opossum and 'coon, for example, and even of blue jay and flicker. I could go on, but another sort of taste prevails.

I now regret such carnage, but not the awareness it spawned. I don't mean mere competence with animal habits, tree identification, the interactions of the natural world's components. It's hard to say what I do mean, but

that competence seems akin to an ability to track my own mental processes, the interplay of one impression with another, as if these things were outside myself, like wildlife sign. To that extent, maybe those reckless early years did prefigure the bookish life I've lived.

Wallace Stevens once described the modern poem as one of "the mind in the act of finding what will suffice." I agree, but I don't think such discovery happens *ad hoc:* one poem, then another, etc. It is a lifelong process involving, precisely, self-abandonment to things outside oneself.

I recall the first book—not a comic or a Dick and Jane sort of story—that I read at one go. It was wintertime of my sixth grade year, and I had a whopping flu. No sooner would symptoms abate than I seemed to relapse. I missed two weeks of school, so sick I couldn't even long for physical activity; yet I had no other resources.

I resisted my mother's dreary exhortations to take up some damned novel. After a week, though, staying inactive, bed-ridden seemed bound to drive me crazy. The topmost volume in the pile she'd left on the lamp-stand was Pearl S. Buck's *The Good Earth.* I started it, an emphatic skeptic—then read right through the last sentence. To my amazement, I had left my normal milieu, in which some version of logic prevailed; as the cliché puts it, I'd been lost in a book.

A pickle jar stood on my bedside shelf. Inside, suspended in alcohol, wavered a copperhead snake, which my mother had decapitated when I was a fourth-grader.

Lord knows why I kept it until I left for college. I have not returned to *The Good Earth* since, in part for fear it would fail to transport me as it did. But whenever I think of my encounter with it, I see the poor headless snake in its jar. I also whiff the cloying odor of fever, see the umbers and beiges of Pennsylvania's November foliage through the window, feel the rough nap of the bedspread, taste the Vicks Vapo-Rub that I roll into pellets and suck. All these are somehow accompanied by a sense of hovering above the everyday world.

I did read a bit more as a teenager, treasuring Ernest Thompson Seton's *Lives of the Hunted* and *Wild Animals I Have Known,* for example, but reading them story by story, not in one rush. I was in college before I read another whole book at one sitting, and then only because I'd procrastinated on an assignment. Yet reading *habits* are not the point.

To get a bit closer to that scarcely definable point, I'll skip next from Pearl Buck to my fifteenth year, when, likely a bit later than most boys, I took up Marjorie Kinnan Rawlings's *The Yearling.* I remember my affection for poor Fodder-Wing, and my awe of Slewfoot the bear, but beyond that my impressions are indistinct. A more lasting one involves a certain claw-foot bathtub. Having reached the part in *The Yearling* where protagonist Jody must kill his pet deer Flag, I felt the heat of tears coursing down my chest into the tub's tepid water.

I have hoarded that state of mind, so to speak, from that day forward. It is part of what some would call my character—and it represents a certain writerly energy that

took me years to understand, however incompletely. It blends in mind with all those associations from *The Good Earth:* I have an inkling for a poem, the snake wriggles in with the flu odor; the rough bedspread coexists with the bath water and the scary bear and the savor of Vicks; the dark oak leaves clap and flutter over the expiring young buck, while Asian men and women in black pajamas look up from their field work.

This is odd and I know it.

One more leap ahead: when I was in my thirties, and literary theory starting to be the rage on college campuses, I found myself in cocktail-party conversation with a colleague, a fellow I liked and still do. He had hopped aboard the theoretical tram, and his take on "literature" (theory puts everything in quotation marks, it seems) sounded mildly intriguing, to the degree that I understood it. But for me it lacked something crucial.

I would have stood no chance in disputation with this more learned fellow, and tried none, but on the way home, passing under the canopy of trees on our dirt road, something came to me. It was not a thought. It was the flu smell; the shudder of leaves; the final breaths of Flag; two young Chinese peasants conspiratorially smiling at one another over the bent back of their aged father; tears in warm tub-water; a savaged serpent; tangy patent medicine—that sense, again, of being overwhelmed by these sensory materials and simultaneously looking *down* on them. Meanwhile, the person designated by the pronoun *I* had uncannily been removed from whatever world this was.

My inadequacy as theorist or scholar hit me like a sledge just then. I couldn't have expressed what I needed instead, still barely can, but I knew I'd have to go after it in a more lyrical way than my conventional professor's role would allow.

Whatever that old complex of associations may represent, it moves me to no analysis. Nor would it submit to analysis. In times that I've approached some recapitulation of it on the page, though, I've felt things to be, to cite Stevens again, "for a moment, final." It's as if my mind has found something that, if only for a mere instant, will suffice.

Why Poetry?

~

PEOPLE HAVE OFTEN ASKED ME, of course, why
I chose poetry as my principal vocation. I like to
joke that it's all about money, women, and fame . . .
which *is*, of course, just that: a joke. The best-selling poets
in America would do well to attract more readers than a
last-place major league baseball team might draw in late
September of a hopeless season.

So there have to be other motives. I could go on at
length about these, but I'll try to distill my thoughts here.

I came to poetry late, not publishing my first collec-
tion until I was forty. Prior to that, I had striven to be a
conventional academic, though from the start somehow,
the whole effort felt a little misguided. I didn't know why
for some time.

In 1970, I was asked to teach a section of Dartmouth
College's first-ever creative writing course, not because of
my credentials—I had none—but because the then chair
of my department, a good man indeed, imagined the gig

would give me time to finish up my Ph.D. dissertation, as I had not yet done. This would not after all be a "real course," he assured me; it would demand neither class preparation nor any scrupulous commentary on the students' work.

And yet in teaching that course (I use the verb loosely), I felt the return of an old itch to write, one I'd experienced in my undergraduate days, when I composed quite a number of short stories. None of these was created for a course, because in the early sixties there were no writing courses as we know them where I went to school either. In the interest of economy, I won't go into my reasons for responding to that impulse by choosing poetry over fiction. Suffice it to say that I did so choose, and though I have written a novel and five collections of personal essays since, poetry has remained my chief métier.

A different and less kindly disposed department chair eventually came to me and indicated that, although my reputation as a teacher was pretty good, Dartmouth had now become a publish-or-perish institution. When I noted that my first poetry collection was under contract, this fellow, not quite concealing his smirk, suggested that, just as creative writing was not a "real" course, a book of poems did not constitute "real" publication.

I'd finished my dissertation by then. In it, I'd sought to ape the suddenly voguish posture of the theorist. For such a reason, it remained an obscure screed, even to its author, whose inclinations were and are, non-, even anti-theoretical. I decided nonetheless to mine the paper

for a few scholarly articles (at that time, one didn't have to offer whole books to meet the publishing requisite), but on reconsidering my own prose, I felt something very like nausea. I recall saying right out loud, "This is not what I want to do when I grow up." I resolved to go on writing verse and to let the chips fall where they might.

I was denied tenure at Dartmouth, but was quickly hired at Middlebury, which had something of a history of writer-professors. This was a better fit. But all that aside, the real question is, why should scholarship have seemed a pursuit so ill-suited to me? I've thought the matter over many times. It was not because I felt contempt for scholarly enterprise; indeed, I still value the training I got in world literature, both as an undergraduate and as a graduate student. And I have published a book of essays that—although I hope it's devoid of jargon and hyper-annotativeness—might legitimately be called a work of scholarship.

No, my choice of poetry had to do with the fact that it more nearly answered to my own mental tendencies. Whereas scholarship, even in its often impenetrable post-modernist avatars, still ultimately depends upon premise and conclusion, upon the dialectical approach, the realm of lyric poetry—at least for me—is roughly described by Carl Jung when he speaks of true psychology as the domain "always . . . of either-*and*-or." That is, lyric can keep multiple perspectives alive within one frame without seeming merely to be a muddle. Perhaps

this is what Keats meant when he famously spoke of Negative Capability, the capacity to live with "Mysteries, Uncertainties and Doubts, without any irritable reaching after Fact and Reason."

Negative Capability, so understood, enables me to indulge what another great poet—T.S. Eliot—called the "necessary laziness" of the poet. To use a reductive buzz phrase, it is a right-brain enterprise. To relax the muscular, either/or approach to experience is to open oneself to unanticipated possibilities, and to let them come as they will.

And to let them come in all their fullness. It may be cliché to say that lyric captures the intensity of certain moments, but so it does for me. This is true, I think, even if the moment that catches my attention never eventuates in a written poem. I know I sound a bit fogeyish to say so (I am in my seventies, and have a right), but the fact that most of anyone's moments are ephemeral and diffuse seems the more evident in the age of Twitter and (the very word speaks volumes) of the selfie. For me, the lyric impulse allows me to see certain "deeper" moments, to concentrate them in what I hope, however vainly or justly, may be memorable language. Among the very deepest of those moments in my own experience, for eloquent example, are the witnessing of the births of five children. The plethora of responses to such events could never be catalogued nor exhausted, but one can go farther toward rendering their impact—or so I believe—via the language of poetry than by any other mode of discourse.

Lightning scarcely strikes every day. If it did, I'd write 365 poems a year. But that it *might* strike at any moment makes me feel alive and attentive, makes me open to all manner of novelty, if I can adequately ignore mundane distractions (and of course I can't; who does?). It feels that such newness is always available out there, no matter I have been recording my responses for more than four decades now. Until I take the long sleep, I'll believe that something fresh may be right around the bend.

Life in Full

~

I WANT TO PAY A BRIEF AND INADEQUATE TRIBUTE to Ruth Stone, my predecessor as state poet. Ms. Stone is remarkable in every way: ninety-six years old and all but completely blind, the woman still generates some of America's most compelling poetry. Compared to her, I'm a mere youngster, just shy of sixty-nine. And yet, like anyone blessed to live past middle life, I feel a profounder sense of loss with every year: dear friends and family die; faculties and physical resources fade; I anticipate more funerals than weddings. I scarcely expect to reach ninety-six, but if I did, such losses as I have known would surely have lost themselves among the multitude that followed.

It is entirely understandable, then, that at her great age Ruth Stone should be a chronicler of sorrow; but in fact she suffered gut-wrenching loss even before she reached

fifty. Her husband committed suicide half a century ago, and to one extent or another, we sense the man's presence (or rather his absence) in all Ms. Stone's work. She has described her own work as "love poems, all written to a dead man." Consider the following:

Poems.
When you come back to me
it will be crow time
and flycatcher time,
with rising spirals of gnats
between the apple trees.
Every weed will be quadrupled,
coarse, welcoming
and spine-tipped.
The crows, their black flapping
bodies, their long calling
toward the mountain;
relatives, like mine,
ambivalent, eye-hooded;
hooting and tearing.
And you will take me in
to your fractal meaningless
babble; the quick of my mouth,
the madness of my tongue.

By my reading, the speaker here finds herself looking forward from winter to the warmer seasons so brilliantly evoked by her meticulous attention to natural detail. That

will be a fecund time, a time when poems return to her; and yet "when you come back to me" seems poignantly to suggest the return as well of an absent lover. The tragic subtext here is that the human "you" will *not* come back after all, that the speaker must settle for what she calls "fractal meaningless/babble."

As I will keep insisting in following remarks, however, more than any other mode of discourse lyric poetry can contain opposite impulses without lapsing into mere self-contradiction. While this is, yes, another Stone poem about grief and loss, and about the resulting erasure of meaning, it's also about "the *quick* of my mouth," the life-force that this valiant woman enacts by means of her own eloquent speech. The "madness of my tongue" is the madness of desolation—but also of exhilaration. The reader can all but hear the sound of spring freshets in her diction.

For me, "Poems" captures in very short span what it is to be human. Our lives do not consist of a simple good day/bad day dialectic, it seems; for as long as we draw breath, we experience pain and fulfillment simultaneously.

Ms. Stone invites my admiration and gratitude: the very music of a phrase like "fractal meaningless/babble" makes me feel more alive, no matter the losses that I, like anyone, have known, and that I am bound to know further.

Two Events

~

I FIND THE MOST TAXING POEMS to construct are those meant to mark an event, because for me the excitement of composition lies in discovering where the act of construction may lead. If I'm certain where I'm going before departure, I sacrifice any such discovery; a closely related problem is that my language and attention are apt to be no more than serviceable in "occasional" poems, mere means of getting from point A to a foreordained point B.

You can imagine my dread, then, at recently having to compose *two* poems of this kind. The first would be for the wedding of our younger son to a wonderful woman. The second—and more daunting—will commemorate the 250th anniversary of my home town, Newbury. As if that weren't enough, I'm asked to ring in Haverhill, New Hampshire as well, the two river towns having signed their charters on the same day in 1763.

In either case, my first notion was that I needed to drag in a lot of history, a need obviously more acute for a poem about settlements two and a half centuries old than for the wedding of two twenty-somethings. But in pondering that seeming imperative, I heard myself droning along; the Vermont poet laureate's recitation would resemble some stuffy, forgotten English poet laureate's paean to a noblewoman. I'd not be flattering royalty, no, but wouldn't I be chronicling the achievements of early settlers, paying homage, for example, to General Jacob Bayley or Governor Benning Wentworth, tracing the history of the railroad and/or local agriculture, pointing out the ancestral home of Boston University on the Newbury common, smiling in one direction or another at contemporary townsmen and—women. On and on. I was putting *myself* to sleep before writing a word.

Now in the case of the wedding, I happened to recall when we first really got to know our son's bride-to-be. The couple was living in Alaska at the time, and my wife and the future bridegroom's two younger sisters had flown out for a visit. At the solstice, we water-taxied to an uninhabited island off the Kenai Peninsula. The place was spectacular, and yet, speaking for myself and (with her permission) for my wife, more eye-catching was the obvious love these two people felt for each other. We noted their shared humor, their zest for the wild world, even their common yen for certain foods. And all this was notable round the clock, *because the sun never went down.*

As I mused, that is, the motif of midnight sun presented itself to me, and while I won't judge the quality of my poem, at least I know it escapes the deadly and-then-and-then-and-then mode, a narrative that might follow our son's development from infancy to matrimony. More crucially, I was able to include his future wife, as a marriage poem should. And the "poetic" link between an unsetting sun and an inextinguishable love-light effortlessly ensued.

In a word, something sensory, something physical, had provided entrée into the nuptial poem. And its example soon got me off scratch with the 250th anniversary tribute. Just as I had literally pictured our group on Fox Island, I began inwardly to picture Newbury and Haverhill, as I'd so often done after climbing up a local hill. From that angle, the most conspicuous landmark is the Great Oxbow, the Connecticut River's miles-long loop between the so-called Horse Meadow on the New Hampshire side and the Cow Meadow on the Vermont.

That intervale makes for some of the richest farmland in the east, as the aboriginal Pennacook nation well knew. Of course, and much before 1763, they were the real settlers, raising maize and squash in the valley until they were all but completely wiped out by imported diseases and white pioneers' military hostility, no matter the yen for peace that their great chief Passaconway showed.

My mind started to rove at will. It hopped to later times, when inhabitants drove timber in great booms

down the river, the oxbow doubtless a significant obstacle. I began to "see" those river-drivers too, and the teamsters who hauled logs out of the woods on ice-roads, and the women who split kindling, raised children, salted food for winter, and educated the young. Now I had a palpable landscape and a visible cast of characters to work with.

I always used to tell my students that just as the word *imagination* includes the word *image,* a poetic world in which imagination can flourish must include something in the way of the visible, merely so that readers understand where they find themselves. As the midnight sun image had led me into the marriage poem, so the oxbow did for the anniversary poem.

In contemplating the latter, it struck me that the oxbow is named thus because it resembles a yoke, and that the yoking together of our towns' citizenries made for an uplifting motif. (I might have used it for the wedding poem too, *conjugal* deriving from Latin words meaning *yoked together.*)

These two occasional poems made me practice what for so long I'd preached in the classroom: history (or philosophy, or religion, or politics, or any other generality, despite that idiot mantra, *Show, don't tell)* is more than permissible in a poem; but in my opinion any such abstraction must be "grounded" in particulars, which tend to be what imagery evokes. For me, the particulars were, respectively, the look of a spit of land in the frigid Pacific and a great meander in a body of water I treasure.

What's the Use?

~

YES, OUR SECOND SON and his wonderful fiancée wed in September, 2012. Unlike me, neither of these young people has much in the way of religion, and yet they put a good deal of thought into the *ritual* aspects of the boding ceremony, whatever that ceremony turned out to look like.

Let me offer an apparent non sequitur. Many, many years back, a very good writing student of mine told me he was headed for engineering school after graduation. When I reminded him of his talent as poet, he told me that composing poetry had been fun; and yet, he asked, "What's the use of it?"

Like my version of faith, poetry is something whose "use" I too have frequently questioned. My poems would suffer if I didn't, I believe. And what I generally come back to is poetry's function, at least in part, precisely to provide our existences with some degree of ritual. (I say this notwithstanding American poetry's longstanding

yen—largely unshared by most other cultures—to sound like conversational speech.)

In Shakespeare's immortal *King Lear,* the king's two disloyal daughters refuse to allow him his retinue of servants, asking why he should need them now. Lear responds:

> O reason not the need…
> Allow not Nature more than Nature needs,
> Man's life is cheap as beast's.

Just as nobody needs a wedding ceremony, which has no use of a practical kind, so no one needs poetry. And yet without some form of ritualism in our lives, it seems to me that those lives are indeed cheapened. In our time of galloping technology, there is no pragmatic reason, say, to send written wedding invitations, let alone elegant, embossed ones; and yet to do so implies some depth that electrons, in my view, will never furnish.

There's a poem by William Carlos Williams called "Dedication for a Plot of Ground." Williams was the *master* of conversational speech, so that his language scarcely sounds ritualistic as it chronicles the struggles, physical and spiritual, of the immigrant woman who owned this seemingly insignificant piece of earth.

But hear how the poem ends:

> She grubbed this earth with her own hands,
> domineered over this grass plot,

into buying it, lived here fifteen years,
attained a final loneliness and—

If you can bring nothing to this place
but your carcass, keep out.

Poetry asks us to slow down and contemplate nuance; it asks us to meditate on the past, with all its ordeals and triumphs and traditions. Poetry hears the echoes of forefathers and—mothers even as it addresses us now. It reminds us, as Williams does in that passage, that we are, or ought to be, more than just our fleshly selves.

That's use enough for me.

Recurring Thoughts
on Rhyme

~

LET ME BE A BIT SPECIFIC about some issues I
face when I visit non-academic venues. There is
none I have encountered so often as the matter of
rhyme in poetry. A grumpy gent in Arlington, for exam-
ple, announced to me that so far as he was concerned, "if
it doesn't rhyme it isn't a poem."

I acknowledged that rhymed poetry was indeed less
common today than once. But I pointed out—gently, I
hope—that rhyme is not a requisite in poetry, nor was it
during much of the art's past. The Homeric classics do
not rhyme, for instance. Neither do the great blank-verse
passages in Shakespeare. In his preface to *Paradise Lost,*
another English Renaissance genius, John Milton, went
so far as to call rhyme "the invention of a barbarous age."
(He was referring to what we used to call the Dark Ages,
the period in which, via Roman Catholic chant, rhyme
first became an arrow in our bards' quivers).

If an author does opt to employ rhyme, he or she

faces a tricky challenge. The poet must use it not merely to keep a particular scheme going, though that scheme, once chosen, must be consistently honored; but also to move the poem along dramatically, even as its language strikes the reader as feasible and apt. One must resist the temptation to facile rhyming, because when rhyme exists exclusively for rhyme's sake, the fact seems pretty obvious to us as a rule, and strikes us as quite lame. I am a longstanding lover of vernacular musical idioms, but must admit that we encounter a surrender to that temptation with considerable frequency in pop, rock, and blues (although—harrumph—rarely if at all did Billy Strayhorn, Johnny Mercer, Ira Gershwin, Willie Dixon, or Cole Porter succumb to it).

I am not the anti-fan of the Beatles that I was back in their early, bubble-gum, sock-hop days of "I Wanna Hold Your Hand," etc., but I confess I'm still no great enthusiast: Lennon and McCartney can, yes, now and then come up with a pretty or a catchy melody, but consider, in one such tune, "I don't want to leave her now"—so far, so all right—"You know I believe, *and how* . . ." And how? Well, Dante it ain't.

Of course, the Fab Four never sin in the manner of the late Jim Morrison, alleged "rock poet" (please!) buried in Pere Lachaise cemetery, of all places (yipes!):

"Like a dog without a bone,/ An actor out on loan,/ " . . . "There's a killer on the road/ His brain is squirmin' like a toad/ Take a long holiday/ Let your children play . . ."

How does one begin to critique such a mess? What on earth is an actor out on loan, and what has he to do with a boneless dog, a squirming toad, and on and on? I could proceed to impugn the poetic genius, as some (to my mind oddly) consider it, of Bob Dylan. I have too many friends, however, who are his devotees, and I don't want to start a fuss with them here or anywhere.

Of course, I am a language nerd. But I think poets *need* to be language nerds. Though many seem to assume that poetry consists of vague and billowy language, I agree with W.H. Auden that its truer aim is to use language that is in fact as precise as possible. That's a hard thing to do when addressing such common poetic themes as death, loneliness, joy, anger, love, memory, and so on. Throw the demand for chiming end-words into the mix and the difficulty grows even more acute.

We nerds wince to hear "his influence can't be understated" when the speaker actually means "overstated." (Has anyone else noticed the current prevalence of this inversion, lately used even by the super-bright Cokie Roberts on National Public Radio?) Please don't tell us that someone addressed a letter to "my wife *and I*." (I recently heard that grammatical faux pas on a BBC broadcast, of all places!) When someone says "anymore" for "nowadays," I mentally red-pencil him or her. Mock me for all that if you like. In my cse, "it is what it is," if you'll allow me an inappropriate buzz phrase traceable to the odious prevaricator and, yes, the odious corrupter of language Donald Rumsfeld.

SO there we are: these sorts of concerns do attract my reflection. (Go ahead, tell me to get a life.) And the other day, as I considered the matter of rhyme, it occurred to me that those most taxed with inventive rhyme are the authors of so-called light verse. In what I have always considered a shorthand response to Rainer Maria Rilke's fabulous poem of the same title, for instance, the late, great Ogden Nash composed this one:

The Panther

> When called by a panther,
> Don't anther.

That is scarcely among Nash's greatest poems—and they are indeed great—but in the interest of space, I use it as a sort of shorthand.

We do not, however, at least to my knowledge, have any eminent light verse poets in our day. Oh, Billy Collins can be funny, all right; so can others as diverse as Stephen Dunn, Marilyn Hacker, and Charles Fort. But comedy is rarely their sole aim. I find this something of a pity, though I haven't the resources to do anything about it myself. I'm told I'm a fairly amusing guy in person, but for some reason almost my every effort to be funny in poetry goes awry.

Here's the strange thing: in order to get their greatest comic effects, light verse poets actually use rhyme that does exactly what I've argued against in other sorts of poetry. That is, often enough, the wackier, more

SEEN FROM ALL SIDES

improbable, more belabored, and glaringly conspicuous the rhyme, the better.

All of which got me to remembering George Starbuck, who died in 1995, and who was sometimes referred to as the thinking man's Ogden Nash. Though he participated in Robert Lowell's famous Boston University workshop with fellow students Sylvia Plath and Anne Sexton, the latters' confessional poems have survived better than Starbuck's technically and intellectually masterful inventions. Even in his lifetime, no matter his first book was selected over Plath's for the Yale Younger Poets series, he had more a cult reputation than a general one. He did not help his own case after Oscar Williams anthologized his "A Tapestry for Bayeux" in the highly influential Little Treasury series, only to drop it when someone told him that the initial letters of the first seventy-eight lines spelled out "Oscar Williams fills a need, but a Monkey Ward catalog is softer and gives you something to read."

I got to know George a bit, because I had been one of three judges to award his "The Argot Merchant Disaster" a lucrative Lenore Marshall Award. I found him a remarkable human being as well as an astonishing writer. For two decades, he valiantly and without any self-pity battled the Parkinson's disease that would kill him at a young sixty-five. Another intriguing detail from his life is described by Eric McHenry in a 2004 article appearing for *Slate*:

> No poet was more scrupulously attentive to words and
> to the ways in which even the subtlest manipulation

of words can bring about seismic shifts in meaning. Starbuck, who was born in 1931, is actually the reason loyalty oaths are illegal in the United States. When the State University of New York-Buffalo fired him in 1963 for refusing to sign one, he fought the university all the way to the Supreme Court and prevailed.

I could make a claim for Starbuck as among the dozen most technically gifted writers in the history of Anglophone literature, but I'll let him speak for himself. Those of us with backgrounds in old-style English teaching will identify with the author here . . . because we are all, as I say, language nerds, sensitive to proper or brilliant or improper or outrageous spellings, word combinations, and usages.

THE SPELL AGAINST SPELLING
(a poem to be inscribed in dark places and never to be spoken aloud)

My favorite student lately is the one who wrote about
 feeling clumbsy.
I mean if he wanted to say how it feels to be all thumbs
 he
Certainly picked the write language to right in in the
 first place.
I mean better to clutter a word up like the old Hearst
 place
Than to just walk off the job and not give a dam

Another student gave me a diagragm.
"The Diagragm of the Plot in Henry the VIIIth."

Those, though, were instances of the sublime.
The wonder is in the wonders they can come up with
 every time.

Why do they all say heighth, but never weighth?
If chrystal can look like English to them, how come
 chryptic can't?
I guess cwm, chthonic, qanat, or quattrocento
Always gets looked up. But never momento.
Momento they know. Like wierd. Like differant.
It is a part of their deep deep-structure vocabulary:
Their stone axe, their dark bent-offering to the gods:
Their protoCro-Magnon pre-pre-sapient
 survival-against-cultural-odds.

You won't get *me* deputized in some Spelling
 Constabulary.
I'd sooner abandon the bag-toke-whiff system and go
 decimal.
I'm on their side. I better be, after my brush with
 "infinitessimal."

There it was, right where I put it, in my brand-new
 book.

And my friend Peter Davison read it, and he gave me
 this look,

And he held the look for a little while and said,
 "George . . . "

I needed my students at that moment. I, their Scourge.
I needed them. Needed their sympathy. Needed their
 care.
"Their their," I needed to hear them say, "their their."

You see, there are *Spellers* in this world, I mean mean
 ones too.
They shadow us around like a posse of Joe Btfsplks
Waiting for us to sit down at our study-desks and go
 shrdlu
So they can pop in at the windows saying "tsk tsk."

I know they're there. I know where the beggars are,
With their flash cards looking like prescriptions for the
 catarrh
And their mnemnmonics, blast 'em. They go too farrh.
I do not stoop to impugn, indict, or condemn;
But I know how to get back at the likes of thegm.

For a long time, I keep mumb.
I let 'em wait, while a preternatural calmn
Rises to me from the depths of my upwardly opened
 palmb.
Then I raise my eyes like some wizened-and-wisened
 gnolmbn,
Stranger to scissors, stranger to razor and coslmbn,

And I fix those birds with my gaze till my gaze strikes
 hoslgmbn,
And I say one word, and the word that I say is
 "Oslgmbnh."

"Om?" they inquire. "No, not exactly. *Oslgmbnh.*
Watch me carefully while I pronounce it because you've
 only got
two more guesses
And you only get one more hint: there's an odd number
 of esses,
And you only get ten more seconds no nine more
 seconds no eight
And a wrong answer bumps you out of the losers'
 bracket
And disqualifies you for the National Spellathon
 Contestant jacket
And that's all the time extension you're going to gebt
So go pick up your consolation prizes from the usherebt
And don't be surprised if it's the bowdlerized regularized
 paperback
abridgment of Pepys
Because around here, gentlemen, we play for kepys."

Then I drive off in my chauffeured Cadillac Fleetwood
 Brougham
Like something out of the last days of Fellini's
 Rougham
And leave them smiting their brows and exclaiming to
 each other

"Ougham!
O-U-G-H-A-M Ougham!" and tearing their hair

Intricate are the compoundments of despair.

Well, brevity must be the soul of something-or-other

Not, certainly, of spelling, in the good old mother
Tongue of Shakespeare, Raleigh, Marvell, and Vaughan.
But something. One finds out as one goes aughan.

Inspiration

~

I HAVE TRIED—with what I consider good reason—
not to talk much about my own poetry in these col-
umns. I make an exception this month only because
I also try to consider the themes and issues raised by my
library visits in Vermont in a serious way. I must give
spontaneous answers in my spoken responses; the col-
umn format may allow me to be both more elaborate and
more precise.

Audience members often ask how poems come into
being, and often inquire about "inspiration." I'm a little
leery of the term, only because I don't want to give the
impression that some Higher Authority is using me as his
or her mouthpiece. In almost all respects, I'm just another
bozo on the bus. But if you'll indulge me, I'll replicate a
recent poem of mine and then say a word about it, and to
that extent about poetry as I understand it, without for a
moment claiming that my understanding is or should be
a universal one.

Abattoir Time

The widower pushed the tailgate shut and fell.
The two sounds—*click* and *thud*—seemed synchrony,
As if one in fact were function of the other.
The red calf, bound for veal in the pickup's bed,
Looked rearward over his shoulder. No one there.
A ginger-hackled rooster, framed by the door
Of the loft, screamed loudly, sun igniting him
To noontime flame. He sent six hens in a dash
For cover under bush and sill, as though
His love-assault might be a thing far worse
Than the farmer felt—or rather did not feel,

The death so quick and commotionless his livestock
Didn't notice. Everything once had purpose
Here, and meaning, and might still have, if only
He'd stayed to read them. Now a skinny cloud
Rode unremarked on a breeze above the barn,
Unsafe and leaning. His horse, a spavined relic
From other ages, whickered behind the house,
All canted too, its paint mere scattered flakes.
Meaning and purpose had blurred in recent years
But the farmer kept right after them no matter.
Who'd free the weanling now, who lead him to
slaughter?

So: how do poems get generated in my mind? Well,
they certainly *never* begin with what, in my teaching

days, students called "ideas." They tend rather to begin with some sensory recall, more often than not auditory. This can be the sound, say, of a certain woodpecker on a very still spring morning; a snatch from an old Monk tune; or, as in this case, most typical for me, a small chunk of conversation that has lodged itself in mind, whether or not I know it.

After a reading last year, somehow an audience member mentioned a farmer of his acquaintance, one who like all small farmers in the era of agribusiness, had struggled to keep his place going, and one who'd just dropped dead while closing the gate of his pickup on a veal calf.

For whatever reason, I vividly heard the *click* of the tailgate and the *thud* of the man's body when it fell.

And then my mind shot back more than fifty years to a farmer whom I had worked for in those old summers. He'd lost his wife and, age supervening, was finding the relentless labor of his calling more and more difficult. He said to me, a boy not yet eighteen, "This place used to have a meaning and a purpose." The *click* and *thud* instantly married that remark, and I fused the two countrymen into one. I had only to fill in the physical details of the farmhouse and farmyard to finish the poem. Whatever its merit, then, "Abbatoir Time" was all but given to me. If that's inspiration, so be it, inspiration in such a case really being a sort of selective memory.

Which leads me to a terse answer to another frequent question: are my poems always founded on my own factual experience? Well yes, of course, who else's? Yet

the facts *per se* may have transpired at different times, in different places. There is, for example, no actual single farmer who experienced the specific moments I render here; and yet I hope my imaginative construct, my blending of two figures, shows a "true" account of a human being in the situation I describe—I hope it is true in the sense of being more or less faithful to anyone's sense of loss and diminishment.

Inspiration II

~

A S I SAY, I'm not quite sure I believe in inspiration, if by that is meant the idea that some higher power has singled me out as a medium. But come to think of it, I do sometimes feel as if I were being drawn along in unexpected ways at that, and it's usually in surprising directions. That's when I abandon myself to my own materials, and such a development can pass in my case for inspiration. It is certainly the greatest payoff I experience as a writer.

Just what, however, do I mean by my own materials? Well, language of course. Its properties can be—indeed, they have to be—my guiding lights above all. Now I know that sounds vague enough. On the other hand, would we charge a painter with vagueness for referring to paint as her material? Who would question a composer's saying that notes were his? You'd think it might seem strange for so many readers (not to mention literary critics and English teachers) to hop right over so self-evident a truth

as that a poet's primary material is language. Too often, they begin their response to a poem by snooping around for what must have been its originative "idea."

On a bad day, especially in "straight" literature classes, I'm sure I've been guilty of such error myself, despite the truth that, at least in my own experience, so-called ideas come after the fact. *Word takes me to idea*–not the other way around. Much of this has to do, of course, with a proclivity I've previously noted: I am a language nerd.

That I am fussy about word and phrase in precisely that way may explain my almost overwhelming delight in having taken part for several consecutive years in the Cabin Fever Spelling Bee, held at Montpelier's Kellogg-Hubbard Library. I have been pronouncer, definer, putter-into-sentences, and judge of the competition.

I've lately been pondering why, the moment that annual event is over, I start looking forward to next year's. The subject of this column is my devotion to language. But such devotion, of course, is personal and not the prime ingredient in the great fun of the Cabin Fever Spelling Bee. There is always a full-house audience, and its members have a lot of pleasures to choose from, not least the beauty and commodiousness of the library building itself. They also sense and contribute to the event as a genuinely communal one. Its meticulous organization is patent: with clarity and eloquence, library board chair Tom McKone explains the contest's rules both to players and crowd; Rachel Senechal, head librarian, sees to every last detail of logistics; Rick Winston, Andrea Serota, and George Spaulding deftly assemble a list of words, which

grows more challenging with each new round of the three.

Of course, the contestants make the event what it is in the end. They are divided into two groups: Vermont readers and Vermont writers. I especially enjoy the good-natured joshing between the camps, and between competitors and me. Before the event, all straight-faced, the celebrated Willem Lange asked me if English was my native language; during the game itself, he remarked that it resembled a cavalry charge: "Every time you look around there are fewer horses." Sometimes the banter is actually among members of one team, and indeed in one case, that of slam master poet Geof Hewitt and his witty son Ben, within one family.

This year, for the second time in a row, the grand champion was young adult fictionist (and so much more), Roberta Harold; the runner-up, also for the second consecutive year, was reader Emily Tredeau. But there was keen competition right along. I think of the bright, poised 85-year-old Maxine Leary, a former school teacher, whose student I would love to have been.

Had there been money involved, I'd have had to recuse myself, as Robbie Harold is an invaluable trustee at Central Vermont Adult Basic Education, whose board I chair. And yet, whatever suspicions may have been felt in any quarter, I simply asked the words I was given in the order they were listed.

But in the end, my keenest attraction to the Cabin Fever bee may well be that language nerdiness of mine, all of which may have started, though I didn't know it

then, in 6ᵗʰ grade Latin class with Mr. Richard Cutler and continued, annually, through the class of Mr. Zygmund Wardzinski, Polish refugee and polymath. Though I was just the sort of adolescent student who made my subsequent choice not to teach at that level a no-brainer, I did do well in Latin. It seemed a silly thing to be studying, yes, but it came to me easily, and I could count on its providing me one of the few easy A's (or any A's) I got back then.

Little did I know that my grounding in Latin (and French, taught by the best instructor I ever had, kindergarten through Ph.D., the late Ted Wright) would be enormously helpful when I elected to teach myself Italian in my forties. Still less could I have predicted how stimulating it would be to sense, almost immediately, the etymological journey of most words I encounter. Though our ancestral Anglo-Saxon was the language of Germanic people in England from the 5ᵗʰ century through the Norman Conquest, its melding of Teutonisms with Latinate idioms (which had already felt the significant effect of Greek ones) have made English a tongue that's full of potential for poets, indeed for all us language addicts.

As words occur to me in a poem, then, they bear the freight of their own history, no matter my German is scanty and my Greek almost nonexistent. To consider that history somehow helps me to surrender to them in the way I've mentioned.

Consider, in fact, a word I used in that last sentence: I mean "consider" itself. Its first syllable, "con" is related

to German "kennen" (to know) and Latin "sidus, sider" (star). Though in our time we use the word very casually, its original value involved knowing the stars.

A related value attends our word "disaster," which literally means an ill-starred occurrence, combining "dis," connoting negation, or "dys," meaning bad, with another root for star, in this case "astrum." The Latin influence is patent (and of course "influence," like "influenza," means a flowing in, for good or ill, from the stars).

We could speak at length of that prefix, "dis" or "dys," and in dis-cussing it, we would be harkening, awares or unawares, to its value up to and through Anglo-Saxon times. A *discussion*, derived from "dis," in this case meaning "apart," and the Latin verb "quatere," "to shake," became "discutere," signifying, literally, a shaking apart. Given the nature of discussion in the contemporary U.S. Congress, say, one might almost believe the word is reverting to its earliest implications.

I could go on and on in this way. It's a bit like finding a favorite song or singer on YouTube: you listen to it or her or him or them and you are reminded of other favorites; you look those up, and in the process come on a musician or a tune you hadn't known. There may be more of my readers who can identify with such a reference (such a "carrying back") than with my own gorging on etymologies and linguistic history. Whatever the attraction, there are clearly enough language enthusiasts to fill up the beautiful main room of the Kellogg-Hubbard Library in Montpelier.

Only Connect

~

I WANT TO REFLECT ON A WRITING EXERCISE I gave
back in my teaching days, not because readers here
are students, but because the remarks may occasion
further thoughts on what poetry after all *is*.

*Select three entries from your journal, no two dated
within four days of each other, and render in a poem
the connection among them.*

I've actually always been skeptical of exercises, which
can too easily be understood as tricks, and although writ-
ing may contain one's personal tricks, it better not *consist*
of them exclusively. Yet I think mine was open-ended
enough to avoid mere trickery.

Let's imagine that on the sixth of May, you saw two
dogs in a vicious fight; on the tenth you broke your toe;
on the fourteenth, it snowed out of season. Okay: Go
for it.

Go for what? Dog, toes, snow—huh?

To many would-be writers have been (mis)educated into believing that literature's aims are abstract, intellectual, or philosophic; thus their greatest block is (quote) "I couldn't come up with an idea." But as my late friend William Matthews, a marvelously inventive poet, once remarked: "Poetry is not criticism in reverse." The writer, that is, does not begin with a concept, then bury it under a lot of lavish language that the reader is obliged to clear away in order to get back to the generating concept. If that's all poetry were, we could just write a prose rendition of the "idea" and go home.

I believe that many of us write to discover our own current obsessions, which may and likely should—prior to putting words on paper—remain obscure even to us. We need the thrill of discovery, and if we don't have it, it's a sure bet the reader won't either. My response to students' complaints about their lack of ideas, then, was—Well, good! Notions formed in advance will rob writing of its potential vigor. The above exercise was designed to free them from the merely ideational into material more properly their own: personal idiom, "musical" effects, and a whole range of as yet unarticulated responses to . . . Life. Their work would not proceed rationalistically but associatively.

In their journals, these students entered things that had arrested their attention. That was the only requirement; I discouraged editorializing or reflection. The three entries on which they based a given poem would be well removed from one another, precisely so that no bossy, pre-packaged idea would get in the poem's way. You see,

the prime defect in most beginning verse, including my own, is its urge to *report* on experience, rather than artfully to suggest the mind and heart in the very *process* of experiencing.

Too many teachers incline to ask, *What is the poet trying to say?* As if he or she had some dreadful speech impediment. The author who successfully completed the above exercise could answer that what she or he was saying amounted to . . . what had been said. (Of course, it ought to have made some sense: see below.) The capital-M meaning of the poem, that is, resided exactly in the language, imagery, and emotional logic that found the connections.

I believed our author could have faith, precisely because she or he was the one to have made these three vivid observations, that there must be a connection among them, and the poem that discovered that connection was its own meaningful gesture. The point was and is to get one's creative capacities off scratch, to prevent a poem's progress from being too strenuously willed.

On a final note, lest all this sound too awfully late-sixties or vulgar-Romantic, I should add that I place due emphasis on the intellect in verse. How could one read Spenser, say, and not? I stress only that intellectual control of a poem is something to apply after the materials have been allowed to float to the surface, as I hope my exercise may have helped them do for my undergraduates. Even though "ideas" inevitably *emerge* from one's poetry, in my view they must not determine it.

Open Questions

~

O N BECOMING MY STATE'S POET LAUREATE, I made it my mission to visit as many of its community libraries as I could. I have paid many, many such visits, and have savored each and all. Certain colleagues at the "prestige" colleges where I taught for over forty years seem always to have surmised that intelligence faded the moment one stepped away from an ivied campus. I always knew that attitude represented the worst sort of provincialism. I am the more assured in that knowledge for the library trips I've made, the more persuaded that there are a lot of smart people out there, however extensive or otherwise their formal education. Perhaps certain of the scholars would do well to spend time among them.

I've especially enjoyed that my audience members tend to ask not the allegedly sophisticated questions, which I've heard more than enough of in four decades of professorship; their questions are more basic, and thus more important, in that they represent concerns that

everyone feels on contemplating a poem for the first time: who's talking? why? where? And so on. For my taste, too much current poetry can't answer those questions on the page, and even as a lifelong lover of poetry, I turn away from such work's obscurantism.

The most frequent questions I hear, however, involve form and meter. There are those who wonder if something can be called poetry if it does not have a regular meter, regular stanzaic shape, and often as not, a rhyme scheme.

Now I am a formalist myself, something not all that common in our day (though I think and even hope this is unobvious when I read, because I pause in my recitation when the grammar does, not when a line does). I even use a goodly amount of rhyme and half-rhyme. And yet I employ these tools merely because they enable me, not because they represent capital-P Poetry.

Indeed, I steadfastly refuse to grind any ax in the free verse/formal verse debate, partly since it seems to it make advocates on either side suddenly go brain-dead. *Of course* poetry can exist in an unrhymed and unmetered format: consider, to pick an ancient and glaring example, the biblical Psalms. *Of course* poetry can be formally constrained without being "academic": never mind my own small example; consider Robert Frost, a die-hard formalist . . . who managed to capture the sound of actual speech far more effectively than an Ezra Pound ever did.

The passionate free-versers may believe that their mode is anti-establishment, a claim that could be made

for it if this were 1920; since then, and surely now, free verse reigns supreme in virtually every academic MFA program and among the most celebrated poets of our time. In short, it *is* the establishment practice.

The other sect of blind debaters, however, alleges that free verse shows sloppy thinking, shoddy technique—as if that applied, say, to Robert Lowell or, more contemporarily, to Louise Gluck. In short, these aspersions are no more or less bright or accurate than those of the free-verse crusaders, who impute coldness, sexual frigidity, political reaction, and—again—"academicism" to formalist delivery—as if any of these charges were relevant to the giants of the twelve-bar Delta blues, a mode that is surely America's greatest formal contribution to world culture, and whose format, in the words of my friend, the excellent Vermont poet Baron Wormser, constitutes the American sonnet.

As I hear the free vs. formal debate rehearsed, I am too depressingly reminded of *political* dialogue in our day. I am never shocked by the slogans on either side of the liberal/conservative divide. It's as though there were no real need for any of us to look at a given issue from more angles than just one: we liberals already know what the conservatives are going to promote; but we fail to see how perfectly predictable our own orthodoxies are.

When I was appointed poet laureate, I claimed in my address that a little humility never hurt anyone. The humble but crucial questions I encounter at the state's libraries assure me that there remain at least a few open minds in the nation.

The Alogic of Lyric

~

MORE OFTEN THAN NOT, in my library presentations I used the following poem by James Wright as an instance of what lyric can do, perhaps better than other modes of human communication. In some instances, the following poem uses language we'd avoid these forty years later, but be that as it may, the poem still seems stunning to me.

Autumn Begins in Martins Ferry, Ohio
In the Shreve High football stadium,
I think of Polacks nursing long beers in Tiltonsville,
And gray faces of Negroes in the blast furnace at Benwood,
And the ruptured night watchman of Wheeling Steel,
Dreaming of heroes.

All the proud fathers are ashamed to go home.
Their women cluck like starved pullets,
Dying for love.

Therefore,
Their sons grow suicidally beautiful
At the beginning of October,
And gallop terribly against each other's bodies.

One can easily imagine the poem as an indictment of a social system that brutalizes its working class (even the night watchman is a ruptured one), and as an ironic lament on the fact that these same sterilized and degraded workers will respond by heroizing their football-playing sons—who in due course, we suspect, will succeed their fathers in the same oppressive occupations.

I believe that lament is surely contained in Wright's poem. On the other hand, *where is the speaker himself?* He is, precisely, "In the Shreve High football stadium." Even as he assails the misplacement of social capital and the physical dangers of the game before him, he is a spectator. Clearly there is another side to the spectacle from which he does not turn in revulsion.

In short, "Autumn Begins . . ." represents the uncanny way in which a single poem can "mean" at least two different things at once. This would be an entirely different work if Wright had merely called the workers' sons suicidal; it would have been different too, if he'd just called them beautiful. But the ambivalence he feels is expressed in what strikes me as the poem's imaginative triumph. These high school heroes are "suicidally beautiful." The violence is part of the beauty, and vice-versa.

I have been pondering this supremely deft work of art a lot lately. Given the season, its football context seems

apt, and its ambivalences are much akin to my own. Of all the three major sports, I enjoy them in this descending order: baseball, basketball, and, at a significant distance after, football. I played the game in high school and on a club team in college, and fact is, I rather enjoyed it. I was pretty big and strong, and the physicality of the sport appealed, even if I was no one's hero. Indeed, as a center, unless I made a poor snap on a field goal, punt, or extra point, I could have the best game of my life without drawing anyone's attention away from the backs and ends.

For all of my more or less fond memories, though, as an older man I find a great, great deal about today's NFL and the big-money college programs that invites my shame and disgust . There is of course the terrible cost to the health of its participants, about which we learn more almost daily. (I am happy that when he was at Oxbow High School, there was no football program there, because I'm sure my second son, much bigger and stronger than I was, would have gone for it.)

There is also the whole ethos of the game, which to me represents those we're-number-one aspects of a United States attitude that most dismay me: the chest-thumping, end-zone-dancing, macho antics; the moral idiocy of a comment like the venerated Vince Lombardi's that "winning is not the most important thing, it's the only thing"; the millions and millions of dollars that go toward this game in a society whose inequities have become more and more glaring in my lifetime (the NFL's inept commissioner being compensated, for a single example, at 44

million dollars per annum); the sheer and vulgar excess of Super Bowl halftime shows I could go on and on.

And yet, come a fall Sunday, I am very apt to be watching a Patriots game. I never do so quite successfully, but I seek to suppress or (what is the same thing) to justify all my profound reservations about football by imagining that the splendor and skill of the game provide adequate reason to be a spectator. In a word, I seek to make myself believe that those players out there are simply beautiful, and to ignore the suicidal (or homicidal) dimension of that beauty.

To the extent that poetry can capture such multi-faceted responses as we have even to the most trivial events, and even in our quotidian lives, it may justify the claim I keep making at those lovely community libraries—a claim for its uniqueness as a type of human discourse. Lyric is an art that gets at the complex working of our minds like no other I can summon.

Little Things

~

IN ONE SAD SEASON at our household, my beloved wife lost her brother, who was also among my dearest friends; Carol Shults-Perkins, the huge-hearted director of Central Vermont Adult Basic Education, whose board I chair, lost her husband; and Char Cutforth, longtime wife of Strafford doctor Jack Beecham, my friend of sixty-eight years, also passed. These were all deaths by cancer, some after long sieges (my brother-in-law had been struggling heroically for twelve years), some all too short (Char was diagnosed in August and died within a few months).

My brother-in-law was known, simply, as Chip. He served as a career police officer in East Longmeadow, Massachusetts. Neither in that capacity nor in any other did he ever swagger; never did he make the least effort to look impressive—and yet he obviously touched countless lives, as was evident at his Roman Catholic wake. Despite the bitter cold, which meant many had to wait outside in terrible conditions for their chances to file through, *six*

hundred mourners showed up at the funeral home to offer Chip and his family tribute. These included, of course, all his fellow cops, but also the full local fire department, the doctors and nurses who had tended him, his auto mechanic, his barber, the guys with whom he'd played club hockey, even the man who ran the local recycling center.

Chip's lovely and bright oldest child, daughter Jen, spoke a compelling eulogy. She referred to the innumerable little things that her father had done for her as he helped to raise her. Some would not consider them manly; to me they epitomize the most humane sort of masculinity. Jen mentioned, for one example, Chip's keeping her in his truck one afternoon during a torrential rainstorm: as they waited almost an hour for the storm to pass, he enthusiastically played Barbie dolls with her; in winter, for further instance, when she was a toddler, as he put Jen to bed he would lie with her on his chest until the mattress had been thoroughly warmed.

Jen concluded by saying, "It turns out the little things were the big things." Amen.

I did not know Dr. Beecham's wife very well, but the bravery and dignity Jack brought to her memorial service in Strafford, the modesty and integrity with which he has conducted a remarkable medical career—all that put me in mind of our niece's conclusion. I knew Carol Shults-Perkins's husband Allen not at all, but every report on his demeanor summons similar thoughts.

After the tribute to Char in the Strafford church, and with the other two sad passings so fresh in my mind, I

found myself calling up two literary passages, ones that as a young and relatively carefree man it seems I'd unwittingly stored. The first comes at the end of George Eliot's magisterial *Middlemarch,* in which the novelist writes of her heroine Dorothea that

> the effect of her being on those around her was incalculably diffusive: for the growing good of the world is partly dependent on unhistoric acts; and that things are not so ill with you and me as they might have been, is half owing to the number who lived faithfully a hidden life, and rest in unvisited tombs.

The other passage is from Wordsworth's famous ode at Tintern Abbey, in which he speaks of how, in "hours of weariness," he may, by way of memory, experience

> . . . sensations sweet,
> Felt in the blood, and felt along the heart;
> And passing even into my purer mind,
> With tranquil restoration:—feelings too
> Of unremembered pleasure: such, perhaps,
> As have no slight or trivial influence
> On that best portion of a good man's life,
> His little, nameless, unremembered, acts
> Of kindness and of love.

My brother-in-law and I had many differences. His politics, say, were significantly to the right of mine. I didn't care about such a matter. I still don't. What matters to me—and what I think each of us, in the effort to lead

"a good man's (or woman's) life," might well consider—is the inutility and even the ruinousness of ego and grandiosity, as compared to the value of those little nameless acts. Whatever the circumstance, Chip could be counted on to do the next right thing. That seems increasingly crucial to me as I age.

I close with the poem I recited at the reception following my brother-in-law's funeral. I don't know whether it's "good"; in fact, I suspect that it may not even be enlightening to anyone lacking personal knowledge of its addressee. But I hope at least it encapsulates the gist of my comments above:

What It Boils Down To
—for A.J. Barone III, RIP

It boils down to this: you will always be young and
 handsome
And strong in our hearts—but above all kind, concerned
For how those around you felt, and this even when
You fought a war that few can so much as imagine.
We two were different: I've lived my life in the mind,
And although you were scarcely less bright, you were
 more the doer.
And you were my hero, still are. There seem fewer and
 fewer
Like you in whose person ethic and deed are combined.
Thought, no matter how lofty, seems duller than lead,
Without heart to match, just as faith without works is
 dead.

You said, no matter how terribly you were tried,
You felt a lucky man. I remember you said
As well—though we all must meet with pain and dread–
The world's best things are happening every day.
You made that clear by the way you smiled on your wife,
On your children, and with pure joy on your two
 grandchildren.
That's one example. If there's some grand kingdom called
 heaven,
As I believe there may be, it will echo life
In what you showed to be its most loving hours.
And those of us who loved *you*—we are scores and scores–
Will take those moments you cherished and make them
 ours.
What it boils down to, though I say as much in tears,
Is that your valor and goodness will light our years.

More on Meaning

~

HERE I INTEND TO MUSE on one of the two or three most famous American poems we have by Vermont's first poet laureate. I want to consider it in part because it is so often read incorrectly—or rather incompletely.

The Road Not Taken

Two roads diverged in a yellow wood,
And sorry I could not travel both
And be one traveler, long I stood
And looked down one as far as I could
To where it bent in the undergrowth;

Then took the other, as just as fair,
And having perhaps the better claim,
Because it was grassy and wanted wear;

Though as for that the passing there
Had worn them really about the same,

And both that morning equally lay
In leaves no step had trodden black.
Oh, I kept the first for another day!
Yet knowing how way leads on to way,
I doubted if I should ever come back.

I shall be telling this with a sigh
Somewhere ages and ages hence:
Two roads diverged in a wood, and I—
I took the one less traveled by,
And that has made all the difference.

This remarkable meditation is forevermore trotted out at graduations, retirement dinners, award ceremonies, and so on, always by way of illustrating the importance of "rugged individualism"—the benefit of bravely taking one's own course in life, of going against the grain if need be.

Such a reductive take on Frost's effort shows a failure of attention to *the poem's own words*, which explicitly indicate that the speaker's choice of a path may be downright arbitrary, the two roads before him being "really about the same." He likewise makes clear some dissatisfaction at not being able to go back and try the *other* path. The poem, curiously enough, is called not "The Road Taken," but "The Road *Not* Taken," as if the author's chief concern were sorrow over his choice. But

logic dictates that if the road he does opt for represents Yankee self-sufficiency, then surely the other represents a sheeplike conformity. So why would he want to try that one too? Why is the one he does take not fairer, but "just as fair"?

In a letter to a friend, Frost observed that "Not one in ten will see the *humor* in the poem." What could Frost have meant as funny here? Well, the humor, I would say, is ironic, designed less to induce laughter than a wry smile in those who get the sly joke.

What joke? Well, let's turn to the final stanza, where Frost predicts that in his later years he "shall be telling" how once "Two roads diverged in a wood, and I— / I took the one less traveled by,/ And that has made all the difference." He'll be spinning such a tale, throwing in a theatrical sigh for good measure, and nine out of ten will *fall for it!*

No, that's too strong. The speaker here is not confidence man alone. If I earlier said that many read this poem incorrectly, I should have said they read it incompletely or *half* correctly, because I think there *is* a lot of Emersonian self-reliance in "The Road Not Taken." It's only that as soon as we choose that and that only as its dominant spirit, the "humor" undercuts our certainty, just as when we try to see the whole effort as an ironic sleight-of-hand, the self-reliant theme rings out.

"If you want a message," Frost once quipped, "call Western Union."

I just said that *logic* dictates the either/or reading of the poem, but the plain fact is that logic is rarely the

right faculty for the writing or reading of poetry; we poets do not labor to produce that single message but a complex of thoughts and emotions. For me, poetry is so true an indication of our hearts' and minds' reality because—as I repeatedly insist—it shows how multi-dimensional those minds and hearts are: the plain fact is that much great lyric entertains equal and opposite impulses *at the same time.*

As an English teacher, I have been as guilty as the next person of asking my students to find "the main idea" of a given poem, and using it to illustrate something solid and permanent. But if the word *idea* has anything at all to do with lyric, then that idea is always ambivalent, rich, varied . . . and thus often even self-contradictory.

Arrogance (October, 2012)

~

L AST NIGHT, just prior to the first of this year's so-called presidential debates, I watched several clips from past debates, ones that chronicled gaffes, bad body language, shifty eyes, and so on. The one that caught my attention showed the much mocked Admiral James Stockdale, Ross Perot's running mate in 1992, who prefaced his debate by asking "Who am I? Why am I here?"

Like most, I suspect, I didn't know twenty years ago that the admiral was one of the most highly decorated naval officers of our time, that he had founded an organization on behalf of POWs in Vietnam. He deserved far better than we gave him. But that's not what I want to talk about here. Though maybe I should have been paying more direct attention (which frankly, however, seemed irrelevant, because I already knew who had my vote), mine is a poet's mind, meaning among other things that it rarely proceeds in a consecutive manner. So the

admiral's question, strangely, got me thinking about who *I* am, why *I* am here. Not that, strictly speaking, these were philosophical issues for me. Rather, I was trying to get a sense of my own personality and character as they reveal themselves via my poetry, which is the only way for many out there to evaluate my make-up.

And yet this is not a one-way matter. In order for me to reveal something genuine about myself or my concerns, I have to imagine something about *you*. I used to tell my students that they ought to do the same: that is, they should dream up or remember or consider the reader they have in mind for a given poem, that people encountering their poetry would learn a lot about it by noting the sort of audience its author sought to reach.

Now there are as many possibilities in this regard as there are poets. I recall the words of a brilliant poet, the late Anthony Hecht, who said that he counted on his reader to know the classics and all the major works of Shakespeare. When I replied that he thereby excluded a huge portion of any potential audience, he rightly answered, "None of us can reach everyone. These are the readers who let me write what I write."

I and my dear friend Fleda Brown, former poet laureate of Delaware, have lately collaborated on a book called *Growing Old in Poetry.* Let me quote her on the theme I am following:

> I ask myself why I'm committing to writing to you, dear reader, as regularly as if you were the ideal mother back when I should have written home and didn't. This

arrogance is what keeps most of us writing, either that, or the fear that we only exist if we keep bringing attention to ourselves.

I'll immediately defend Fleda against her own accusation: she is anything but arrogant. But she is surely onto something here. In my own case, I like to imagine my reader as our nearest neighbor Tink, scion of a seven-generation Vermont family, a man of ninety years. Now Tink *is* a reader, one especially fond of Louis Lamour, but he's not, so far as I've ever known, a reader of anyone's poetry, including my own, though we are real friends. No, my supposition makes no sense whatever. And yet it is an enabling fiction; it allows me to write what *I* write, to feel that I am a man saying something to another person, one whose wisdom and wit I admire, one with whom I would want to share personal information.

And if I speak to Tink in my head, I am reminded that he is not one for obfuscation or beating around the bush. If you address him, you need to be clear about what you mean.

Conversely, I often found among my students, even the most talented, a tendency, in the words of Friedrich Nietzsche, to "muddy the waters to make them appear deep." (I fear that a lot of so-called established authors do the same.) They wrongly worry that if they just say things directly, they'll show a self that is boring, non-"poetic," and thus they leave out essential information about their implied characters, not least about the one named *I*. The

result, I believe, is too often that we can't really care about such shadowy figures as appear in their pages. Or at least I cannot myself. If some non-specific voice is speaking about non-specific psychological or emotional issues to some non-specific listener, I am inclined to find some other conversation. The willfully obscure writer leaves us listeners out as he or she proceeds. That writer may seek mystery, but such a quality is in fact only possible if surface clarity is available to us. (Think of such a matter with regard to a genius like P.D. James.)

To give the impression that you, mere reader, must possess some arcane knowledge in order to "get" what is going on behind my smokescreen strikes me, to use the term that Fleda Brown misapplies to herself—well, it strikes me as arrogant.

Poets and Farmers

~

O N ONE OF MY COMMUNITY LIBRARY VISITS as poet laureate, I was delighted to meet a certain Vermont farmer: he was no refugee stockbroker or other sort of wannabe, unconvincingly duded out in farm clothing. No, this fellow was the real thing—redolent of the barn, possessed of the wonderful old-time accent now vanishing into the world of screen culture and robotized telephone calls. I'd noticed him holding a book during the presentation, and now I asked him about it. The volume turned out to be Frost's *Mountain Interval.* When I said how I prized that volume, he gently challenged me: "How many poems can you say from it?" I boasted that I could likely do three entire, to which he replied, just as gently, "I can say 'em all."

Indeed he could, as I gathered from quizzing him, not on "The Road Not Taken" or "The Oven Bird" but on less famous things like "An Encounter" or "The Gum-Gatherer."

That moment remains a joy to recall, and I got to reflecting on it lately when I came upon yet another poem from *The New Yorker* that proved inscrutable (at least to me). At the start, and not for the first time, I worried that, being just shy of seventy, I was falling into the age-old geezer's trap: if it's new and I don't understand it, then there must be something wrong with it. Clearly poetry editor Paul Muldoon, a bright and decent guy, sees qualities in such poetry that I don't. I try to be decent, but maybe I'm not bright—or at least not anymore. But.

But let's consider a non-*New Yorker* poem by Rae Armentrout, who in 2010 won the Pulitzer for poetry.

And

1.
Tense and *tenuous*
grow from the same root

 as does *tender*
in its several guises:

the sour grass flower;
the yellow moth.

2
I would not confuse
the bogus
with the spurious.

The bogus

is a sore thumb

while the spurious
pours forth
 as fish and circuses.

Ms. Armentrout is associated with a movement called Language Poetry, which sees itself as more "postmodern" than postmodernism proper, whatever that may be. Its adherents, guided in significant measure by Gallic literary theory, claim that what we call "meaning" is merely an artifice, that we're misguided to see any direct relation between a word and what it refers to. Language controls meaning, not vice-versa.

Now part of this conviction seems accurate, but at the same time, once you get by the jargon, also pretty darned simple. Anyone who has written "creatively" for a week—or anyone, period—knows that you can't type the word *hamburger,* for example, then sit down and eat the thing. Having waded through the theory, you arrive, I think, at truism.

As I keep saying, I'm old enough now that I don't much care anymore what the professionally hip think of my opinions, so I don't risk much when I suggest that there's a lot of hooey involved here, or, if not hooey, at least misprision as to what poetry can and should accomplish. Would the farmer I described at the outset take time to memorize Ms. Armentrout's poem? I'm betting not, but does that mean he is fool or Philistine? Again, I'm betting not.

A lot of us poets may lament our relative dearth of readership, blaming it, say, on American consumerism, the blight of screen culture, and, precisely, philistinism; but too few of us turn the lens on ourselves. If we want readers, we should be readable. This means in part that we must be generous enough to invite non-specialists into our poems. When he read the most famous entry in *Mountain Interval*, I'm certain my farmer at least understood how the poet once stood at a fork in a woodsy road. That's specific and clear in context. When I see a specific reference in "And," however, I can't contextualize it at all.

Fish? Circuses?

Let me quote the speculation of another prominent Language poet. Lyn Hejinian tells us that

> Language is nothing but meanings, and meanings are nothing but a flow of contexts. Such contexts rarely coalesce into images, rarely come to terms. They are transitions, transmutations, the endless radiating of denotation into relation.

I once had some obligation to follow this sort of commentary, and I can still more or less do so. But would my Frost-loving farmer—or any of the other bright, book-loving folks that show up for my library talks—be enlightened to know that the experience of *Mountain Interval* is one of witnessing "the endless radiating of denotation into relation?" I have my doubts.

And here, for me, is a related irony. The theorists of much inscrutable contemporary poetry bill themselves as

political leftists. Listen to their rhetoric, and you'll find them dead set against elitism and traditional authority. But just as I noticed how few "progressive" professors at the local prestige college volunteered, when the economy went bust, to have their six-figure salaries reduced in the interest of retaining jobs for cooks and groundskeepers and custodians, I notice that these cutting-edge poets and their advocates seem rather indifferent to the tastes and pleasures of the very people whose dignity and rights they claim to champion.

But maybe I am just confusing the bogus with the spurious.

Poem as One-Liner

~

What Followed Your Birth

You might not like being reminded
of your birthday, Father said,
but your mother & I do. Your
birth was a happy occasion.
What followed was both good
& bad. That was to be expected,
but what we didn't expect was
that you'd be the last of your friends
to get a job, which you still haven't
gotten yet. It just took you longer
to get started. You had to go back
to school. That wouldn't have been so bad
if you were learning something, but
after all these years to still not know
what you want for a present doesn't
speak well for education.

This is a poem read by Garrison Keillor on "The Writer's Almanac" a month ago. Am I alone in finding it pretty bad? More radical still, am I alone in finding that with Keillor's temporary succession by Billy Collins as selector of poetry for the show the quality of those daily poems has improved significantly?

Mind you, I owe not a thing to Billy Collins, am repaying no debt here. Indeed, Collins's anthology excludes me entirely. That doesn't matter a bit. It's a good anthology, considerably better, I believe, than Keillor's own *Pretty Good Poems . . .* which also excludes me. (A lot of poets who regard themselves as sophisticated dislike Billy Collins himself. Not me. I like him a lot at his best, and rarely dislike him even at less than his best. My suspicion is that the sophisticates' real beef with him is that he is—gasp—so popular.)

Keillor's problem, I think, no matter I'm grateful for his fixing the radio spotlight on poetry, even my own, is that pretty good often tends for him to be the high bar, with notable exceptions like poems by a William Matthews or a B.H. Fairchild. Thus, many of the poems he has chosen go under that bar and thus are as weak as the one above.

Why do I call it weak? Well, it seems to me that a good poem can make us contemplate the same situation from several different angles of vision, and—this is of course becoming a themein these pages—*it can do so simultaneously.* That's among poetry's real distinctions, and for me, its delights. The poem reproduced at the outset, on the other hand, resembles nothing so much as a one-line

joke. Such a joke may occasion laughter— I personally don't even get a snicker out of "What Followed Your Birth"—but after you've heard it once, you aren't apt to go back to it.

Of course, we all know that Billy Collins writes jokey poems himself.

The History Teacher

Trying to protect his students' innocence
he told them the Ice Age was really just
the Chilly Age, a period of a million years
when everyone had to wear sweaters.
And the Stone Age became the Gravel Age,
named after the long driveways of the time.
The Spanish Inquisition was nothing more
than an outbreak of questions such as
"How far is it from here to Madrid?"
"What do you call the matador's hat?"
The War of the Roses took place in a garden,
and the Enola Gay dropped one tiny atom on Japan.
The children would leave his classroom
for the playground to torment the weak
and the smart,
mussing up their hair and breaking their glasses,
while he gathered up his notes and walked home
past flower beds and white picket fences,
wondering if they would believe that soldiers
in the Boer War told long, rambling stories
designed to make the enemy nod off.

What's so deft about this poem, it seems to me, what so completely distinguishes it from the other, is not the genuine laughs it provides; nor is it the sad commentary on how feckless we are in our efforts to sustain innocence amid a world of war and bullying; nor is it the evocation of the teacher's palpable awkwardness; nor is it the ambiguity of the teacher's person (are his motives noble or craven or—most intriguingly—both? does he seek to delude the kids out of concern for them or because he is lazy—or, again, both?). No, it is the coexistence of all these motifs, and more, that makes it so successful.

The humor is part of the pathos, and vice-versa. The teacher's fumbling efforts echo those of the poet, who is also trying to make everything, including his poem, come right against all odds. And the author's language, so apparently and deliberately artless, seems to me exactly on the money. How much sadness and hope and despair, what brute realism and what longing are compacted into a passage like this:

The children would leave his classroom
for the playground to torment the weak
and the smart,
mussing up their hair and breaking their glasses,
while he gathered up his notes and walked home
past flower beds and white picket fences . . .

The very imagery of the picket fences and the flowerbeds strikes me as brilliantly selected. Conversely, it

seems notable to me that the poem I quoted at the start contains no imagery at all. It appears, that is, to be unconcerned with creating a flesh-and-blood world in which we may, so to speak, move around and live and breathe. Its poet is too eager to get to the punch line; everything that precedes is mere set-up for that.

The author of "What Followed Your Birth" is first and foremost, I'm informed, a slam poet, and that fact allows me to respond in a general way to something that's often asked of me in the Q&A following one of my presentations. What do I think of slam poetry? Well, fact is, I like it. I think it's entertaining. I have even heard a slam poem or two that I felt was—if scarcely in a class with "The History Teacher"—well, pretty good. But by its very nature the slam format seems often to call forth the likes of the poem to which I am objecting here: a poem whose aim is for quick and clever effect. Given its circumstances, we can't expect such a poem to be genuinely contemplative, as, I think, the Collins poem above proves in the end to be. Nor can we expect it to invite genuine contemplation from its hearer.

Perhaps Garrison Keillor was attracted to "What Followed Your Birth"—and to several others by the same writer that he has read over time in his NPR slot—precisely because he is a man who has himself made a career of improvisatory, quick effect, usually of a comic kind. He is, I'll grant, more than just pretty good at that.

English teachers—and once more I don't exempt myself from the very charge I level here—often make a distinction between technique and content, form and

substance. For a writer, I'd argue, this distinction is a false or at least an impoverished one. Were we to "translate" a poem by Emily Dickinson, say, into free verse format, all that we vaguely label its meaning would be utterly altered, all that—with equal vagueness—we call its music would evaporate. It's the way that its words are put together that makes it poetry, after all.

I'm wary, as my readers and hearers know, of asserting that a given piece of writing is "not poetry," period. And yet, though perhaps I am wrong, I can't imagine a loss of any kind to the poem with which I opened if it were simply written down as the prose passage it so starkly resembles.

You might not like being reminded
of your birthday, Father said,
but your mother & I do. Your
birth was a happy occasion.

Would anything be sacrificed if the "Your" of that third line were dropped to begin the fourth, which would seem its proper place anyhow? Or consider

to school. That wouldn't have been so bad
if you were learning something, but

Is there some imperative for "to school" to be juxtaposed with "That wouldn't be so bad"? And why on earth does the next line end on so inconsequential a word as *but?* So on.

All right. I don't mean to whip any dead horses, and again, I don't want to pose as the assured authority I scarcely resemble, even (or especially) to myself. I simply believe that the poem I have criticized fails to provide the rich and various perspective I treasure in good lyric, and that its language is utterly undistinguished. But maybe what I'm really getting at here is: Welcome to the "Almanac," Billy, for however brief your time there. Be well, keep doing good work, and keep on keeping in touch.

Professionalism, Diversity, and Other Modish Matters

~

NOT LONG AGO I attended the annual conference of the Associated Writing Programs in Boston. I have disliked this conclave for years now (on which more directly). AWP comprises almost all the creative writing programs, graduates and undergraduates, in the US and Canada. Now I'd be a hypocrite to rail against such programs after all my years in service to several of them, but when I consider that there were eleven *thousand* attendees, I ask myself if there are that many serious literary artists in the two nations, or is the age of Creeping MFAism engendering ... something else?

If one were to judge by the conference schedule alone, it would be hard to conclude that the graduates of such courses of study were meant first and foremost to be artists. That schedule was overwhelmingly devoted not to literary endeavors but to how one might get a job—generally academic—somehow connected to them or otherwise advance in the "profession." There seemed, then,

a whole lot of talk about poetry and fiction from that professional perspective, sadly little from an aesthetic. I noticed a slew of people checking out my name badge and quickly comparing it in terms of career potential, with that of person behind me. The effect was a bit alienating.

Admittedly, I am scarcely as pure as the driven snow. I showed up too; I have shown up at AWP if, as was the case this year, I had a new book to sign or if someone I like a lot had asked me to take part in a reading or panel discussion. But I do feel a bit soiled every time I attend, never more so than in 2013, and I don't believe that even these inducements will get me there again.

This set of thoughts segues, I hope, into another issue, though you may have to strain a little to follow my free-floating narrative. In any case, I ran into a fellow whom I find rather congenial, and whose poetry I generally favor. I asked him to catch me up on what he'd been doing in the half-decade since we'd seen each other. He said, with something of a weary sigh, that he now chaired the graduate writing program at a certain upper New England university. Another member of the group asked him how that was going, and he allowed it was a decent job, but added, with a bit of a smirk, "I live in Cambridge, thank God."

Now I'm the one who thanks his own God that he lives in Vermont and *not*, say, in Cambridge, but also one who'd as soon avoid contention, so I held my tongue as he rambled along, and rightly, about the opportunities for theater, film, music, and so on. His chief pleasure,

however, was that he lived in a place that exemplified diversity.

Diversity. Like "closure" or "appropriate," this is one of those contemporarily over-used words that, frankly, tire me out a bit. Diversity, we are told, is a virtue, and it's not that I have any doubt (I don't) of the claim. It's just that it ought to be used with some respect for its meaning. Without resorting to blanket judgments myself, I must say that the sort of Cantabrigian with whom my acquaintance hangs out, to judge by his own description and my own past observation, lives in about as non-diverse a world as I can imagine in light of that real meaning.

Yes, there is surely a greater ethnic and racial diversity in his neighborhood than in mine, but I'd bet my hat that, in his back-and-forth between university and the environs of Harvard Yard, he scarcely shares a word or an opinion with friends and colleagues (including racially or ethnically divergent ones) that's not unreservedly embraced by them. If you know what one of these folks, thinks, for example, about gun laws, you can safely extrapolate not only his but also his companions' opinions on abortion, foreign policy, religion, and on and on. All their kids have gone, or will, to college. Both spouses have done the same. They share musical and culinary tastes. Indeed, these citizens seem even to dress rather alike.

This, apparently, is their notion of diversity.

Things are otherwise in my small upcountry town. In that allegedly homogeneous community, I must not only tolerate but also listen carefully to attitudes that

are, well, diverse. I have friends whose politics don't just differ from mine; they offend mine. These are, none-theless, dear friends. I come into constant contact with my beloved nearest neighbor, for example, a ninety year old, retired from a long, hardworking life as the installer of siding. My favorite hunting companions have long been an auto mechanic, a carpenter, an architect, and a fly fishing instructor. My church congregation includes several farm families, an insurance man and woman, an oil delivery man, and a retired state cop, just to cite a few.

My wife and I have a circle of particularly close companions that includes a public high school teacher, the CEO of his own organic fertilizer company, a bank vice-president, a woman skilled in home restoration and upholstery, a teacher's aide at the elementary school, a mediator—and a state poet. Farther afield, for another instance, we are not bosom pals, by my barber and I have had a cordial, respectful, longstanding relationship, and we have a handful of common interests. Same with the local garage-man, the couple who run the general store, the neighborhood bank tellers, the librarian, the gifted heavy equipment artist who lives just across the river, the rare book vendor, the lawyer, and so on.

To circle back, if I can, to my impressions of that writers' convention, it seemed to me, as I played mouse-in-the-corner, that all around me I heard, as it were, the same language. The participants had nearly identical career objectives. They shared social views. Etc. Theirs appeared to me, in short, a guild mentality, or maybe more accurately, a sort of over-populated cabal, in which

the . . . well, in which the diverse people I just catalogued would likely find little footing.

That is a sad fact for a poet to contemplate. It's no wonder that the Common Reader (as Virginia Woolf called him/her) is more and more a fiction. "Literary" authors spend the better part of their time in the academy and the hip community, which is to say in each other's company. To that extent, their opinions are rarely challenged or asked to justify themselves, and theirs becomes, to an alarming degree, an insiders' idiom, available enough to those who speak it, bizarre or just off-putting to those who don't. Too many of them (with, of course, noble exceptions like Ted Kooser or Mary Oliver) converse with their like-minded peers so exclusively that they mistake their groupthink for originality, no matter it's the opposite, and confuse their own preoccupations and convictions with those of a wider, and, again, a more diverse society. I fear, too, that often this strange elitism sneaks, or even bolts, into their written output.

H.L. Mencken once suggested that Henry James needed a good whiff of the Chicago stockyards so as to get a little life into his novels. I don't want to go that far, believing as I do that James was a great novelist; nor would I ever want to pose, absurdly, as some proletarian spokesman. Still, I think you catch my drift. . . .

Another Mild Rant at Theory

⁓

THOUGH I OUGHT TO AVOID SELF-ADVERTISE-
MENT, here's the title poem of my most eleventh
poetry collection. I hope I can quickly explain
my motives for quoting it.

I Was Thinking of Beauty

I've surrendered myself to Mingus's *Tijuana Moods*
on my obsolete record machine, sitting quiet as I sat last
 night.
I was thinking of beauty then, how it's faced grief since
 the day
that somebody named it. Plato; Aquinas; the grim rock
 tablets
that were handed down to Moses by Yahweh, with His
 famous stricture
on the graven image. Last evening, I was there when
 some noted professor

in a campus town to southward addressed what he
 called, precisely,
The Issue of Beauty. Here was a person who seemed to
 believe
his learned jargon might help the poor because his
 lecture
would help to end the *exploitations of capitalism*—
which pays his wage at the ivied college through which
 he leads
the impressionable young, soon to be managers,
 brokers, bankers.

He was hard above all on poems, though after a brief
 appearance
poetry seemed to vanish. It was gone before I knew it.
The professor quoted, *Beauty is Truth, Truth Beauty,*
 then chuckled.
He explained that such a claim led to loathsome
 politics.
I'm afraid he lost me. Outside, the incandescent snow
of February sifted through the quad's tall elm trees,

hypnotic. Tonight as I sit alone and listen, the trumpet
on *Tijuana Gift Shop* lurches my heart wih its
 syncopations.
That's the rare Clarence Shaw, who vanished one day,
 though Mingus heard
he was teaching hypnosis somewhere. But back again to
 last evening:

I got thinking of Keats composing and coughing, of
 Abby Lincoln,
of Lorrain and Petrarch, of Callas and Isaac Stern. I was
 lost

in memory and delight, terms without doubt nostalgic.
I summoned a dead logger friend's description of cedar
 waxwings
on the bright mountain ash outside his door come
 middle autumn.
I remembered how Earl at ninety had called those
 verdigris birds
well groomed little folks. Which wasn't eloquent, no,
but passion showed in the way Earl waved his work-
 worn hands

as he thought of beauty, which, according to our guest,
was opiate. Perhaps. And yet I went on for no reason
to consider Maori tattoos: elaborate and splendid,
Trinidadians shaping Big Oil's rusty abandoned barrels
to play on with makeshift mallets, toxic junk turning
 tuneful.
The poor you have always with you, said an even more
 famous speaker,

supreme narcotic dealer no doubt in our speaker's eyes

eyes that must never once have paused to behold a bird,
ears that deafened themselves to the song of that bird or
 any.

Beauty's a drug, he insisted, from which we must wean
 the poor,
indeed must wean ourselves. But I was thinking of
 beauty
as something that will return—here's Curtis Porter's
 sweet horn—

outlasting our disputations. I was thinking it never had
 gone.

Now as I have gotten older, I have more and more
sensed the inutility, and even the inhumanity, of polemic.
So although at some level, the poem above suggests my
skepticism of what has passed for literary study in the
past generation (and not coincidentally contributed to
the precipitous decline in college English majors), I trust
it does so by indirection.

If literary study was once devoted to aesthetics (which I
acknowledge as itself a reductive perspective), it has lately
been transformed into a facet of what's called cultural
studies. And a recurring theme in those studies is that
"established" authors, past and present, have tended to
be mouthpieces for racism, sexism, economic repression,
and all the other usual suspects. The poem notes with
some irony that, although capital-C capitalism tends to
be a major villain in such trendy theory, the majority of
its most radical critics seem to work not in community
colleges, in impoverished public school districts, urban
or rural. No, they preach at places like Harvard, Yale,

Brown, Stanford, or Duke. (To which I respond by thinking, well, talk, no matter how high-minded or progressive, is as cheap as ever).

Conversely, isn't it strange that so many of our canonical writers, those reactionaries and repressors, seem to have been very ill served by what they allegedly championed? I think, for example, of the older Melville, for all intents and purposes chalking X's on travelers' bags at the custom house he manned, and in the end being called *Henry* Melville in his *Times* obituary; of writers from Hart Crane to Ernest Hemingway to John Berryman taking their own lives, many besieged by alcoholic despair; and the list could be almost infinitely protracted.

But having dispensed with such oddities, and too quickly, I concede, I need to consider something more central: namely, that I have yet to meet a single cultural-studies theorist who had even a faint clue about what goes into the actual composition of poem, story, novel, or even non-academic essay. How, then, can they so confidently discuss a process that's utterly foreign to them?

In order to make such an observation, however, I'm merely reversing the microscope through which the trendy critics look at *us*. Essentially, as the brilliant Marilynne Robinson has pointed out, their assumption is that we don't know what we are doing, that we are somehow mindless serfs in service to great cultural forces that we can't grasp. (Isn't it curious how the most brilliant of our artists remains unaware of their intentions, while the theorists are so sharp that their own are infallibly well informed?)

To be fair, there is some truth to one part of that notion of artistic unawareness. In my own case, at all events, I never know where a piece of writing is going, at least at the outset. In that sense I am, yes, unaware. Or I'd better be: if I'm too clear on where I'm headed, I will experience no discovery in whatever I fashion; I will simply have illustrated ideas or convictions I already knew I owned.

A more serious charge from the hip professoriat is that some of us artists know damned well that we are promoting ideology, of a sort that by the theorists' lights must inevitably be ugly. And yet, no matter I'll grant that some writers are ambitious to illustrate "political" ideas acceptable to their constituencies, that some do have agendas and theories of their own, the work that results is almost without exception as dreary as you might expect. This is not a matter of left or right, reactionary or progressive. Check the annals of Soviet socialist realism if you doubt me, or the work of Hitler's small but slavish cadre of artists.

I would insist that few truly memorable pieces of writing have ever derived exclusively, or even primarily, from theoretical premises or from ideology. Writers may, of course, generate theories and even elaborate them into the ideology; but I think such theoretical postulation tends to arrive *ex post facto*. I'd claim that Ezra Pound's "imagism," for example, ensued upon his writing a broad range of lyrics in an instinctive way, and then erecting his manifestos based on what they showed him. I bet even he was surprised.

I know, of course, that any modish theorist who reads this will instantly charge me, again, with not knowing what I am up to. I number quite a few such folks among my friends, after all, and I've learned that for me to deny their aspersions is merely to convince them further of my ignorance. That's a frustrating experience, a bit like denying your Oedipal instincts in a Freudian's presence. He (Freudians are all but inevitably male) will attribute your denials to repression . . . which of course owes itself to your Oedipal anxieties.

The final irony: all those "progressives" behave (in word if not deed) as if they were champions of the downtrodden and the oppressed. But, to repeat myself, they spend virtually all of their time in one another's company. Though I won't for a single embarrassing minute pretend to be a worker-poet, I have spent a lot of my life, for reasons I needn't go into, in the presence of the dispossessed, especially of people who—talk about downtrodden!—are illiterate or subliterate. It's telling to me that—like the African-Americans in our own South who picked up the musical instruments jettisoned by retreating British military bands and produced music that's the jewel in America's cultural crown; like the Trinidadians in my poem, who took the rusted barrels left behind in the wake of Big Oil's Caribbean exploitations and turned them into steel drums: like these other oppressed people—our contemporary society's most destitute and most "culturally deprived" seem perennially to treasure story, song, lyric.

They cherish beauty, that shibboleth of reactionaries.

But of course, I guess, they incline to the beautiful, or to rich narrative, or to memorable character, simply because they have not had their eyes opened by the ones who speak for them so gallantly, from behind the ivy.

"What Is the Poet Trying to Say?"

~

I WAS FLATTERED over my time as state poet by read-
ers' expressions of hope that my newspaper columns
might be collected in book format, as here. I was
also a bit surprised: a late-comer to poetry as a mode of
inquiry, which seems a reasonable way to describe it, I
still find it remarkable that anyone should be concerned
with my opinions about it.

Still, I will self-advertise to the extent of saying that
a book of literary criticism by my hand, *A Hundred
Himalayas: Essays on Life and Literature,* is available from
the University of Michigan Press. Its essays are more
expansive than the newspaper ones could ever be, and
they cover a span not of four but of almost forty years.

In those four decades, I've been both teacher and poet,
each function a blessing to me, and furthermore, I hope,
honorable pursuits. In selecting essays for the book, how-
ever, I confess I had a qualm or two. That, I concluded,
accounted for my having so long deferred their presenta-
tion between covers.

Why the qualms? I've already hinted at one reason: my depressive's sense that no one would be much interested in my opinions and speculations. But that was less compelling a reason than another, namely the ambivalence I feel even about old-fashioned practical criticism, whether my own or others'. Not that I don't enjoy it—I do, a lot—but that I sense the critic's grasp must always fall short. Or rather, it often becomes so inventive that it's less a response to any given text than it is its own hybrid art form. The critic's response, that is, turns primarily into something on his or her mind, which is likely altogether different from what a given author had on his or her mind.

But what, really, does any author have in mind?

A common question I've heard over the years, from aspirant commentator, person-in-the-street, and academic specialist alike, is "What is the poet trying to say?" It's as if she or he had some terrible throat disease. There's a way in which a good poem itself is what it seeks to say: the poem is its own "meaning."

And yet, when all is said and done, that meaning must in some respects remain obscure. When the obscurity is part of its design I grow impatient with it, as you will have seen; but if it has anything going for it, even when a poem seeks precision and lucidity it is surely at least other than one-dimensional. Forgive me for plucking on the same string once again, but no translation of its "ideas" will account for its power.

Truth is, I believe that an ambitious poem will possess its own hidden allegory, an allegory hidden not only

from the reader and/or critic *but also from the author.* Oh, that author may tell you what gave rise to this or that piece of writing, and may do so in entirely good faith. But I insist that the poet's explication of the work's origins must always be far less than complete.

In my own case, for example, I may claim that a recent and as yet unpublished poem was tripped off by my observing a particularly outsized oak leaf, and the claim is at once "true" and totally insufficient. The poem does somehow illuminate aspects of my own spirit that I didn't know were nagging at me, but it is powerless to render them in full. Yes, I noticed that oak leaf; but what in me turned it into something important (at least in my own heart)? I confess I don't know. Why, say, should that leaf have arrested my attention more than recent news of a drought's effects on a part of Kansas that I have come to love? Why more than our oldest grandchild's recent birthday? I don't know. I just can't.

Let me illustrate my thinking here by reference to another example from my own work, which it took me a long time to comprehend even in part. In the early eighties, my younger brother died suddenly of an aneurysm. He was in his early thirties, so needless to say, this catastrophe was just that, coming, so it seemed, out of nowhere. One unsurprising effect on me was a rather protracted abandonment of poetry. What, I wondered, was the point of art in face of something against which it would forever be ineffective?

Six months passed. I was out hiking with my dogs. One of them came upon some piece of rotten nastiness

on the woods-floor and, doglike, began to roll in it. This put me in mind of a situation that by then lay well behind me. Five years before, a certain local clan had gutted a deer directly across the dirt road from where my family lived, leaving the offal to putrefy. I was and am a hunter, so it was not the kill that bothered me; it was that they would leave that mess for my dogs to gobble up and, to put it genteelly, to redeposit inside our house.

The clan in question was a hard-luck, hard-living kind. One of the sons would shortly die in a hideous car crash; another had beaten a neighbor to death during a drunken party, and had only lately been sprung from behind bars. In a word, these were not men whom, if you had any sense, you hauled onto the carpet. I let the whole matter pass, having scooped up the deer's paunch and hauled it deep into the woods several miles away. In that moment, however, half a decade later, I imagined what might have happened if I had protested, imagined how an escalating controversy between their family and my own would have turned out.

When I got home, I sat at my desk, the urge to write seeming to have returned. I then wrote a poem called "The Feud," in which I played out a fantasy of violence. When I typed the last word, I sat back, my body literally shaking. I wrote the poem, which ended up at fifteen typescript pages, in an hour, and, uncharacteristically, revised it virtually not at all before publication. Once I found the almost laughably simple narrative scheme—*they* do something, I retaliate; *I* do something, they retaliate—the poem appeared to write itself.

Being a good Puritan, of course, I was certain that anything that came with such apparently small effort could not be any good. As the cliché has it, I hadn't earned it. And yet various confidants pronounced "The Feud" one of the best things I'd accomplished.

Now here was the sort of hidden allegory I've referred to, though it took me about eight more years to see it, and though I'm sure I still see it incompletely.

The relationship between the *I* of the poem and its hardscrabble antagonists was very much like my actual relationship to my late brother. We were the closest of five siblings in age. We were also the most adversarial. I was something of a scholar and an athlete, which caused him to construe both those endowments as bogus and even odious. As I understood years after his tragic death, my smug sense of myself as his superior was much akin to the self-styled decent-honest-God-fearing narrator's sense of himself vis-à-vis the unfortunate neighbors with whom he feuded. At the resolution of the poem, that narrator has an epiphany: namely that all the virtues he has ascribed to himself are in fact paltry as measured against the grand moral stakes of his family, his community, and even the universe.

The poem came so quickly, I now believe, because without even knowing it, in a manner of speaking I had been doing research for it for six months; indeed, I had been doing that research all through the course of the life I'd shared with my poor dead sibling.

How would a pile of guts have led to such an insight? I still don't know. And even as I present this plausible

account of what my own hidden allegory was, I am conscious that no matter the passage of thirty years, I have at best decoded a mere fraction of it. So don't tax yourself if you feel that you often don't "get" this or that poem. You have a lot of company.

High Art and Schlock

~

I WAS AT A GATHERING NOT LONG AGO—the venue isn't important—when I heard a Marine recite a poem. He'd been struggling after getting home, and small wonder: twice deployed to Afghanistan, he'd also been twice wounded, one of those times pretty critically. He told us that the poem in question had kept him going through several horrific ordeals.

I think the poem was called "Hope." It was awful.

For all its clichés and bromides, however, that poem had been a literal life-saver for this man, so by what right do I call it awful?

How do I claim the superiority of "high art"? Speculation on such matters provides a subtext for this brief reverie, in which, as in the others, I mean to avoid strong opinion, making clear that my judgments are that, period: *my* judgments, hence not ones with any special authority. So as I consider quality vs. awfulness here, I mean primarily to raise an issue, not to offer some pat

and prescriptive solution to it; I'm far from convinced that one is available.

Driving home after that meeting, I got to thinking back some twenty years, when my wife and I were sitting one evening in a backcountry restaurant. Apart from us, there were only three patrons: a mother, her adult daughter, and her son-in-law. The daughter had composed a poem for her mom's birthday, and we couldn't help overhearing it. This poem, too, was awful. And yet her mother was moved to tears by it.

After that restaurant experience, I started now and then to conduct a contest in my introductory writing classes. At the time, there was a saying abroad, adopted from the "Peanuts" comic strip, I think: *Happiness is a Warm Puppy.* The prize went to the young man or woman who could use it effectively in a poem.

Why should that have been such a challenge? Well, I was and remain a dog lover; my wife and I have three in the house just now, which is in fact a rather low number for us historically. And yes, as a rule, they make us happy. They can also be colossal pains in the you-know-what, and never more so than when they were puppies: those unwelcome deposits on floor and rug; those chewed chairs and cushions; that yapping in the predawn hours. And so on. Happiness Is a Warm Puppy? Oh, yeah? Tell me that while I'm cleaning up after one or another of these catastrophes.

The point I tried to make to my students was that generality and abstraction of such a sort were perilous

territory for poets. They can too easily be argued with. But I suggested by implication that it might be possible for so apparently trite and equivocal a phrase to make its way into a piece of writing without sounding merely saccharine, without inviting that ready *who says so?* response. In short, I meant to advise the students that there might after all be room in their work for abstraction, generality, and so on.

Over the years, too many of us teachers have unthinkingly mouthed that old workshop-worn saw, *Show, don't tell,* despite the fact that the dictum scarcely holds up under scrutiny. Would anyone really have advised John Keats to leave "Beauty is Truth, Truth Beauty" out of his ode on the urn? Would anyone have chastised Emily Dickinson for telling and not showing when he or she came upon "Publication—is the Auction/ Of the Mind of Man," or Yeats when he or she read that "The best lack all conviction while the worst/ Are full of passionate intensity"? No, poetic lines like these—lines that unabashedly tell—are more than simply allowable; they, and many rhetorically similar ones, constitute some of the most memorable lines in English-language poetry.

Abstraction/generality in and of itself, then, is not what causes problems, not what invites contrary argument, not what causes a poem to wallow in gushy sentimentality. The difficulty arises when there is nothing *besides* generalized diction. When that's all there is, we hear an unsettling echo of Hallmark card verse.

By my lights, the voice of the poem must not float free of the occasion that spawned it.

In short, I believe, generalized diction needs to be *grounded:* we have to know what lies under it. And, related, as the old buzz phrase of the sixties put it, we must know where the poet is coming from.

Truth is, I found myself profoundly moved by the awful poem recited by that brave Marine, precisely because I knew that's what he was, a Marine, and one who'd suffered grievous wounds in his service. I was moved by the daughter's birthday verse too, precisely because I could *see* the dramatis personae. I was in the physical presence of thinking, feeling individuals.

"Serious" poets, however, must provide that sort of presence within the poem. Maybe they should think of their words as being delivered to an anonymous reader, one who cannot be expected to know the composition's circumstances on the basis of anything but the composition itself.

We so-called serious poets ought not to write, I believe, in the manner of the woman in the restaurant or the Marine. But maybe we are obliged to contemplate why such "bad" poetry seems to have such a grip on many a hearer or reader. Our allegedly refined sensibilities cannot themselves float free of the common circumstances we confront as a species. That Marine and that daughter must, so to speak, somehow be introduced into our work, or rather, some element or another has to provide the equivalent of their living, breathing, human attendance at that gathering or at that restaurant.

To elevate our work above the modes we dismiss, perhaps too facilely, I think we must let our listeners in on where our poems are coming from. If we don't, the result may not be sappiness; but we may well stray in a direction that, to my mind, is at least as undesirable: aloofness, snottiness, or worst of all, impenetrability.

An Ecology of the Book

~

WHILE RECENTLY CLEANING UP MY HOME OFFICE (which might be known to classical scholars as the Augean Stables), I came on this short reverie, which I'd committed to the page in anticipation of completing a collection of unfashionable essays, from which it was ultimately excluded. Its opinions belong to a man of seventy-three (sixty-eight back when he wrote it) who is perhaps too set in his ways and who bristles at change. Make of that what you will. Its sentiments are quaint, I know, but still heartfelt.

On Bibliodiversity

I am no theorist, nor even a man who thinks well about philosophy, politics, or social policy in their broader avatars. My testimony, then, is only that of a writer devoted for the most part to "minor" genres.

There I stood at the top of a small local mountain in rural Vermont, where I live, the snow deep, brilliant, crossed only by tracks of deer and coyote. I was in my

latest sixties, and had just sold my ninth book of poems to an independent publisher, its editor/director the most sensitive and competent I've known.

There was some satisfaction in that, but just then another project announced itself to me: a book of essays on certain people and landscapes of Vermont, and of people and territory in a part of remote Maine where my family has had a fishing camp for four generations.

Many of those people would be well over a hundred if they still lived, men and women so attuned to their backwoods environments that in memory I still find it hard to tell in their cases where human nature ends and actual nature takes over.

Their culture and particularly their *narrative* skills have all but disappeared now, and none of them left a written account of those lives and times; yet they meant so much to me as man and artist that I felt I owed them a tribute.

An evil voice asked, *Who will publish a book like that?*

A better voice replied, *It's what you want to write, so write it!*

As it happens, a certain New York house has since that morning expressed interest in that very volume.* This is a "niche" publisher, which caters to readers with similar enthusiasms to mine—canoeing, fishing, hiking, hunting. There appear to be enough of them that the house can survive on sales alone.

*See *A North Country Life: Tales of Woodsmen, Waters, and Wildlife* (Skyhorse Publishing, NYC, 2012).

To most publishers of poetry, non-academic literary criticism, personal essay, and short fiction, however, government support is increasingly crucial, and here's the rub: the American hagiography of The Market. Despite the fact that unfettered U.S. capitalism had lately produced disastrous effects at home and world-wide, an article of Market Faith remained and remains: if it sells in plenty, then it must be valuable. Efforts, especially from the Republican party, to stifle the National Endowments for the Arts and the Humanities, crucial supporters of work that does not meet the market standard of value, are therefore unrelenting.

Given the Latin etymology of the word, with its emphases on *saving* and *together,* it strikes me as bizarre that the congregants in this faith regard themselves as "conservatives.'"

As I stood on my snowy eminence, I remembered doing so on other hills when I lived farther south in the state. From there, my prospect today would be onto out-of- scale new houses . . . or else much older ones, lived in by single families for generation upon generation but now belonging to relocated suburbanites, who have entirely altered them and their surroundings. These new-comers seem oddly intent on transforming what they fled to into what they fled from.

In a word, downriver from me a demographic revolution has occurred, native families—the ones so brilliantly limned by Robert Frost—forced out, consumerist culture imported, along with such notions as that no real town can endure without a five star restaurant, and so on.

This is conservatism, this sundering of community and tradition in the interest of real estate profits and appetitive consumption?

A warning about the extinction of upper New England's hill people may have less glamour than an elegy on the indigenous people, say, of the Amazon basin; and yet the juggernaut of The Market and of Globalization is assaultive of both.

Where am I going with such apparent divagation? Well, the social transmogrification to which I've alluded in Frost's territory (and in the Latin American rain forest) makes a lot of money for certain non-local entrepreneurs. Similarly, if one looks at the best seller list of the *New York Times*, one finds it dominated by what we call page-turners, books that have scant regard for felicities of style or intricacy of narrative but seek, in effect, to ape the pace, dazzle, and formulaic quality of television, film, and now the so-called social networks and video games— in a word, books that, to the delight of large interests, sell in a hurry and in large numbers. As with real estate, what makes the most money becomes what's most important.

And yet some of us keep insisting on writing and reading the minor genres, on the related urgency of language both precise and lyrical; we go on living, at least metaphorically, in precious and vulnerable little houses, which may be razed or remodeled beyond recognition when the global market's juggernaut reaches them, as surely it must.

With respect to writers and readers of American poetry, for example, these little houses have been and

become more and more the sort of little *publishing* houses that I have stuck with throughout my long career—with one disastrous exception: I once sold a collection of poems to a trade company, only eight per cent of whose assets lay in publishing as we once knew it; the corporation, or so I was told by my excellent editor there, actually had much more invested in food for pets than in poets.

My book sold well by my measure . . . but not nearly well enough to avoid rather quick consignment to a shredder; the pages I'd labored on were then turned into paper towel (another of the company's investments). That fine editor got fired, probably for taking too many books like mine. The bean counters wanted an eighteen percent return, and neither I nor my poetic fellows would be contributing much to that.

I've never had such an experience with a small press. And yet, as I have hinted, these presses are heavily dependent on financial support not only from individuals of means but also from state and federal sources. It's not hard to imagine what may become of them if the dismantlers of such support for the arts prevail.

Of course it behooves these publishers, along with their writers and readers, to pressure political representatives for aid to our less commercially viable arts. But I suspect, to make an analogy, that just as many more people probably watched bear baiting in Shakespeare's time than watched his great tragedies, so today the poet, the essayist, the short fictionist all appeal to constituencies

whose political power is paltry when stacked up against The Market or Globalization or—what is for us the same thing in many respects—the producers of those page-turners.

Do I sound like a pessimist? I am.

Now it may well be that our future lies in the world of cybernetics: online publishing, electronic books, Google, what have you? I am all but innocent of that world, my own computer, for example, serving me solely as a very high quality typewriter and a machine for sending and receiving e-mail. So I can scarcely offer an opinion one way or another on such a score.

If that is literature's future, however, I may live long enough to miss the feel of an actual book in my hands, the capacity physically to turn its pages, back as well as forth, and to regard favorite old volumes as they in turn regard me from their shelves. I'll miss the tiny Woodsville Bookstore across the river in New Hampshire, from which I buy all my reading materials, and with whose cheerful and literate proprietor I share tips on new authors; the Internet purveyors will have forced such a shoestring operation into nonentity.

As I stand and look out from any local promontory, it is all too easy to imagine an immense, garish, and costly modern structure standing in the vista, like some grand Random

House looming over the crumbling small houses and shops of my actual, my metaphorical, my spiritual village.

Jean Connor

~

NOT ENOUGH PEOPLE IN VERMONT (or else-where) know that a miracle dwells among them. I am referring to a profoundly gifted and—the adjective seems inevitable—spiritual poet named Jean Connor. Ms. Connor is 94 years old, and it was not until her 86th year that her first book, *A Cartography of Peace*, was published by Passager Press, which has the commendable mission of publishing poets who are emerging after their 50th birthdays.

I have only met the woman once, when she did me the exquisite honor of attending a presentation I gave to Champlain Union High School students. I look forward to spending more time with her when I visit Wake Robin retirement community in Shelburne, where Jean now lives.

The poet received an undergraduate degree from Middlebury and a graduate one from Columbia. Thereafter, she worked as a librarian for more than three decades in New York State. It was after her retirement that

she began vigorously to write poetry. But although I speak of her vigor, which is a subtle one, in fact her deep strength as a poet resides to no small degree in her quietness, her gift for contemplation, her utter lack of presumption. Hers is not a poetry of razzmatazz. It may be refreshingly accessible on first reading, but in order to capture its full resonance, the reader must take on the quietude of mind that is a hallmark of Ms. Connor's work.

This is not an easy attitude to strike; one must have the patience that she herself exhibits in seeing a wide world in what is simply, and often all but imperceptibly, right in front of our noses. As my friend, the Pulitzer poet Stephen Dunn, has said, "She has the rare gift of being able to startle us with equipoise . . . "

Consider:

Of Some Renown
For some time now, I have
lived anonymously. No one
appears to think it odd.
They think the old are,
well, what they seem. Yet
see that great egret

at the marsh's edge, solitary,
still? Mere pretense
that stillness. His silence is
a lie. In his own pond he is
of some renown, a stalker,
a catcher of fish. Watch him.

So many of us–poets no less than the hardest-striving captains of finance or industry or academe–seem bent on being as *un*anonymous as we can be. "Of Some Renown" reminds us of the opportunity that lies in relative anonymity, which in this poet's case is all but identical with humility. She knows it's wrong of so many to dismiss the old, for example, as "well, what they seem." Notice, however, that this poem does not rail against such cavalier and shallow judgment; rather it turns for ratification, characteristically, to something outside the author's self, something that will subtly illustrate the uniqueness of everyone and—thing, and not just aged human beings. Her refusal to rant and rave, in my opinion, is what makes her terse commandment at the end of this lovely piece of writing reverberate as vividly as it does: "Watch him."

Jean Connor is—if we will let her, if we don't make the egregious mistake of confusing her deliberate inconspicuousness with any sort of blandness—a supreme watcher herself, and, whether we are aspirant writers or not, a supremely endowed *teacher* of how to watch. As she herself has said, "There is a sense of dedication. Writing is part of my effort to become fully myself, to understand myself and my world more deeply. Poetry for me is less stating a truth I already know, than finding a truth I want to share."

One can't help noticing that the wonderful mixture of modesty and brilliance in Jean's work, so patently connected to that very quality of dedication, has something

to do with her spiritual convictions. Whether we share them in any doctrinal way or not, that Jean Connor is somehow lit from within, that she has both experienced and exemplified what her fellow Christians call grace, is everywhere evident:

When the Time Comes

My epitaph should read
I was surprised by grace.
It bore no face,
only radiance and joy.
Incise the words on stone,
or better, in your heart,
and, to please me, sketch
two birds to sit within the text.
Please write this down. "I never
expected such song. It was,
but it was not, orioles singing
in the orchard of His grace."

I can't of course speak for anyone but myself, but Ms. Connor—here and in many other places—has incised her words in my heart.

*In fact the Woodsville Bookstore I thought I'd miss somewhere down the road vanished within a year of my composing this piece.

Jean Connor (Reprise)

~

ITT HAS BEEN ALMOST TWO YEARS since I celebrated one of Vermont's literary treasures, Jean Connor. I find myself inclined to do so again just now, for no especial reason save that I have been rereading her lovely 2005 collection, *A Cartography of Peace*.

I'm not sure I can improve on the jacket comment composed by my friend and former Vermont College colleague, poet Robin Behn, who notes, with exquisite accuracy, that "only some art knows how to teach us how to live, and in a way that we are . . . ardently willing to be taught."

Robin is right to include Ms. Connor in this company. Though we were all once cautioned by W.H. Auden that "poetry makes nothing happen," I find things happening to me right and left in *A Cartography of Peace*. Ms. Connor, given her wonderful modesty, will likely balk at hearing me say that hers is a poetry of moral instruction. But it is in fact the same modesty that allows this sort of

instruction: her lessons on how to live both a practical and a spiritual life are obliquely offered, without a trace of superior posturing. Her poetry demands attention, because one can easily miss the thematic forest for the trees of her keen observations, particularly of nature. Consider, for one of myriad examples, her response to a natural harbinger in "Late August":

> Then, not as an intruder,
> but as one accustomed to the place
> the hour, a cricket began to sing,
> steady, sure, and as he sang
>
> the world slowed to meet
> his pace, found itself webbed
> about in peace. The grasses
> sleep-heavy, wet with dew.

As I say, one can profitably dwell on the sureness of notice here, but as we meditate on these passages (and I'd say that Connor's poems demand, precisely, meditation,)—as we meditate on these words and many others in her opus, we understand that the beauty and clarity of her language is itself the product of a meditative soul.

There is simply no physical context, nor, so far as I can see, any season that does not evoke from this fine author a contemplative and ultimately redemptive response. In "Now, in March," for instance, she speaks of a month that many of us in upper New England might consider the year's most irredeemable.

Outside, drifts of brazen snow
and the bitter hour glass of cold.

Inside, pressed against the pane,
pots of green and the first white
geranium, tenuous, unfolding.

and hidden deep within, the stubborn
candle of my will, ablaze,
steady, before that duality,
death, a February thing, and life,
which reaches out to April
and on occasion sings.

There is such quiet brilliance here! If we recall that as
of the publication of this, her very first book, ten years
ago, Jean Connor was eighty-six years old (at ninety-six,
she continues to write beautifully and again, as Robin
Behn put it, to instruct us in living fully)—in light of
such a fact, it is easy to suppose that the poet herself
would be the "bitter" one, that her urge to write would
itself be "brazen." But no, those attributes belong to the
apparently inauspicious landscape. Ms. Connor is subtly
"stubborn," not brazen; she wills herself to see and to sing
about those things that can, if we allow them to, sustain
us. Thank fortune for such song!

My object here, however, is not literary criticism
but appreciation. The poet's own words are convincing

enough on their own, and I believe I do well in this respect to quote another short poem in full:

Overcast
The day, of no great merit,
ended—a dandelion gone to seed,
minutes squandered, hours spent,
no bright gold. Yet in the ledgered

plainness of the day, overcast, common,
some subtle brush of meaning
held me. Was it those unexpected
words of thanks, or the single lilac

plunged in a paper cup,
there on a stranger's desk?
Something, a fragrance,
lingered well past dusk.

When I consider so much contemporary poetry, which seems premised on hifalutin intellectual theory, and which glories in mere wordplay, I wonder, can its authors, let alone its readers, such as they are, possibly be moved by what is presented on the page? Jean Connor's poems move me greatly, in part because her intelligence is clearly profound, but she wears it lightly and gracefully, thereby implying—to my mind rightly—that intellect alone is not in the end, as Wallace Stevens said, "what will suffice."

I'll close with an observation, based in part on the passages below, that by some may be considered quaint, even sexist. So be it. I say it only because I believe it: Jean Connor's verse is feminine. I use that adjective in a way that is nothing but honorific: her work is short on ego, astoundingly attentive to eloquent detail, and in the end based on charity in the same sense that Paul describes it in Christian scripture. She manifests a love so uncanny that the mere word "love" can't describe it. To my mind, that quality is what causes the world to go round, and though she herself makes no effort to describe it, this wonderful poet somehow simply knows how to enact it.

In a poem aptly entitled "The Women," she notes, among other things that

. . . there are more women than you might imagine who
take care of old men who have forgotten
the names of the women
and the names of the sons and the daughters.
These are the men who are not sure
of a spoon. Sometimes they can be told
how to hold and lift it.

I urge any reader of this appreciation to read *A Cartography of Peace*, whose value I reduce by suggesting a single overarching moral theme. What we learn from the woman's personal and artistic example is the value, not of resignation, but of acceptance. What is immediately before us, no matter what it be, is what should demand our participation.

Nothing here should surprise us.
More women than you imagine
teach themselves to live
in that slim space between now and tomorrow.

Jean Connor is one of the women who have taught themselves how to live in that space, and having done so, she can teach us all, male and female alike.

Did Dante Drive
an Outback?

~

HE FRENCH POET Stephane Mallarmé once
opined (T.S. Eliot would echo him in his mag-
isterial *Four Quartets)* that poetry's object was
to "purify the language of the tribe." I've been thinking
about that lately—less, though, in response to any poetic
text than to a wonderful prose one, Henry Beston's
Northern Farm (1948), a chronicle of seasonal life in and
around the house that the author and his wife shared on
Lake Damariscotta in Maine.

Anyone who has ever considered her- or himself in
the least a naturalist writer knows Beston's classic *The
Outermost House*; by her own account, for example,
this was the only book that directly influenced Rachel
Carson's composition of *Silent Spring*, itself so influential.
Yet I was ignorant of *Northern Farm* until it turned up on
a shelf at my late, wonderful mother-in-law's house in
western Massachusetts. Much of the author's prose sim-
ply stuns me, and I am in sympathy with many of its
tendencies. Consider the following:

One of the greater mischiefs which confront us today is the growing debasement of the language. Our speech is a mere shadow of its incomparable richness, having on the one hand become vulgarized and on the other corrupted with a particularly odious academic jargon. Now this is dangerous. A civilization which loses its power over its own language has lost its power over the instrument by which it thinks.

Amen, said I to myself as I pondered these assertions . . . a response that among other things surely proves, as I must acknowledge, how men and women of an age like mine have always thought and will always think "the world nowadays is going to hell." But.

But what is meant, for example, by "Chevrolet, an American revolution"? Was it General Motors that impelled Washington across the Delaware in that cold, crucial winter? For shame. Or "Love—it's what makes as Subaru a Subaru." Did Dante drive an Outback?

This is the sort of thing that Beston called vulgarization. Loathsome though it be, however, it can't compare to a passage like the following, cobbled together by a professor—Lord, help us—of English at a prestigious university:

If, for a while, the ruse of desire is calculable for the uses of discipline soon the repetition of guilt, justification, pseudo-scientific theories, superstition, spurious authorities, and classifications can be seen as the desperate effort to "normalize" *formally* the disturbance of a

discourse of splitting that violates the rational, enlight-
ened claims of its enunciatory modality.

Contemporary literary theorists such as our professor
here have pointed out that words never bear more than
an oblique relation to what they are meant to signify. But
it is unclear to me exactly what the obfuscatory words
just cited may refer to, even obliquely.

In reading Henry Beston, in relishing his straight-
forward yet lyrical style, it occurred to me —hardly for
the first time—that alienation from the tangible world,
including the alienation of language from that world, is,
as he says, dangerous. I am more and more convinced
that the farther we get from our physical realities, the
more radically we make the (false) distinction between
our bodily and spiritual lives, the more we pay for it.

We can turn to—well, goofiness, the kind evinced,
in my opinion, by the unreadable prose of the English
professor just quoted, though his is only an instance, and
sadly not a particularly extreme one, of the argot used by
the theorists who have carried the day in our humanities
departments. These tend to be men and women who
speak so densely and abstractly—and all but exclusively
to one another—that their language bears no palpable
relation to the world of people who live in very different
circumstances. Theory among the academicians, I sur-
mise, is so motivated by their need to say something new
(an imperative that would have baffled, even alarmed,
the scholars of antiquity, by the way) that I can't help

supposing they must themselves at times feel suspicious of their own assertions.

Here's Henry Beston again:

> When I am here by myself . . . , I read the agricultural papers and journals which have been put aside in the kitchen cupboard for just such a solitary night. I never read (these) without being struck by the good, sound, honest English of the writing, by the directness and simplicity of the narratives . . . Whether the topic be tomatoes or ten-penny nails, their writers know how to say things and say them well.

But wait: I am not mounting an argument for simplism any more than Beston is; I scarcely regret that Emily Dickinson, for instance, was not a poultry farmer. I am simply reiterating my claim that disembodiment, alienation from our physical and natural world, results not in higher thinking but in impoverishment or obfuscation or, again, goofiness. This seems to me even truer for poetry than for most modes of discourse. I'm put in mind of Ezra Pound's claim, which, granted, is only a half-truth, even if the true half is deeply compelling: "the natural object is always the adequate symbol."

Speaking of which, could anyone, as poet, fictionist, or practitioner of any other sort of language, be more eloquent than Beston in this passage from *Northern Farm?*

> A gold and scarlet leaf floating solitary on the clear, black water of the morning rain barrel can catch the

emotion of a whole season, and chimney smoke blowing across the winter moon can be a symbol of all that is mysterious in human life.

Yet there are greater dangers than mere inanity, and I fear they grow ever more acute in a technologized age. Silly or vulgar jargon can offend, and even wound, to be sure, but not so much as certain modes of cool calculation. The drift into disembodiment allows us to imagine the victims of military attack, for example, as statistics, not as living and breathing organisms, to look at citizens as parts of this or that voting bloc, not as individuals with their own idiosyncratic virtues and flaws.

Argot, that vicious cool, or—what? I guess the word that comes to mind is creepiness. On a recent trip to our Maine cabin, my wife and I picked up a Bangor paper at the village store. In its so-called Family section, a young woman who had just borne her first child described how she was going to chronicle the little girl's early years. The first thing she did was to open a Facebook account for her daughter, which would be waiting for her when the time came. She likewise established an email for the child, to whom she had been writing e-notes every two weeks. There were other cybernetic measures she meant to take, but I have mercifully forgotten them by now. I am no Luddite, mind you. I have become as dependent on the Internet as many others. At the same time, just as we did our children, my wife and I have lately been savoring our little grandchildren, five of them now. This

involves not only the (wearying) fun of frolicking, at a playground, in the woods, on the living room floor or wherever, more than snuggling close to them as we read bedtime stories and entertain their wonderful comments and questions. It also involves giving baths, wiping chins and bottoms, feeding and cleaning up after them—all those physical gestures, pleasant and otherwise, that go into close human interrelationships

Emailing the kid before she can read a word? That *is* creepy, right?

Or am I just a superannuated, sentimental old fool?

The truth lies doubtless somewhere in between. Wherever it may lie, out my window just now, I see a small hooded merganser diving under the surface of our pond and re-emerging, making small ripples that clash mildly with the wind-driven wavelets. The duck's behavior seems enough, when I get right down to it, to make a day.

Translation

~

NOT LONG AGO, I collaborated with the superb Canadian poet John Lee on a few poetry events in Ottawa. One of these was a reading and discussion by interactive television with some francophone poets and intellectuals in Québec city. Their questions were bright and challenging, and, in my case, because I had rendered several of my own poems into French, several had to do, precisely, with issues of translation.

I have strong opinions on the matter of translation, the strongest of which one might think unassailable: if you are going to translate a poem from another language, you'd better *know* that language. The idea, oddly, is not universally accepted. In the 1980s, James Dickey, for example, offered up a set of "translations" from the Hungarian, a notoriously intractable language— of which he was utterly innocent. Another volume, published at the end of the twentieth century, offered twenty translations form the *Inferno,* the majority of

the translators distinguished contemporary poets, to be sure—and innocent of modern Italian, let alone that of Dante's era.

But these translators had precedent: Ezra Pound's volume *Cathay* purported to render a sheaf of classic Chinese poetry, though Pound knew little if any Chinese. Rather, he took certain prose summaries and turned them into poems of his own device. Some of the results, like "The River Merchant's Wife," are lovely; but they are—in the typically witty words of my late friend Walter Arndt, eminent Dartmouth professor, polyglot, and himself a gifted translator—"not translation at all, properly so called, but a sort of verse prospecting with native beater."

To most of my readers here, I suspect, controversy over what does and doesn't constitute translation is of small urgency, and I don't mean to dwell on it. Rather, in translating myself, in seeing the issue, so to speak, from farther inside than ever, I came to reflect on less specialistic themes, especially my longtime conviction (hardly original) that *how* something gets said in verse is as crucial to what we call "meaning" as any other aspect, perhaps more so. I emphasize such a claim only because, as I have mentioned repeatedly, so many of us are apt to construe poetry as a vehicle for philosophy, psychology, what have you? It's hardly that a poem *can't* contain such elements but that it does not consist of them *exclusively*. We mustn't imagine that prosody, indeed the simple choice of certain words themselves, involve mere window

dressing, ornamentation to be swept aside in the interest of finding some underlying theme. To see poems in that manner is to miss a lot of their power and pleasure.

A prose Dante, to revert to perhaps the greatest of all Western poets for an example, would not be Dante at all. Robert Bly's free verse renderings of formal poems by Rilke may be to your taste (not mine), but they are Bly poems, not translations.

Yet again, for my purposes here, this issue of translation suggests a common issue for poems in any language, namely the relation of form to content. For poets, however, this is a distinction without a difference. Alexander Pope's attempts, however misbegotten, to offer up Shakespeare not in blank verse but in Augustan rhyming couplets may have been interesting, even diverting, but the Bard's meanings, I insist, were patently changed by such rhetorical alteration. Imagine a metrically rigid Walt Whitman! A prose-poet Emily Dickinson! Understand, for further instance, how, when he set aside his earlier formal manner for a more open one, the great James Wright's meanings changed too. I could go on.

As I've insisted before, all artists depend primarily on their primary materials: for painters, it's paint; for musicians, notes; for dancers, bodily gesture; so on. There is no way to skip over these, either for maker or witness. The primary material for poets is language, so it's odd that we sometimes look past this basic element in our search for something "deeper" or "hidden" or whatever. Doing so, we miss poetic essence.

All of which may be a too wordy way of getting to my chief recommendation: I urge you, especially if you find poetry forbidding or otherwise off-putting, to read any poem you encounter out loud before over-pondering its possible significance, or seeking to "get it" otherwise. You may be surprised how far into such work your very ear may lead you. Before you realize it, you may just get it in a way you hadn't foreseen.

Slowing Down

~

IN MY YEARS AS VERMONT'S STATE POET, I wrote some forty of these columns. I received innumerable responses, most of them blessedly supportive. (There have been some of the other kind, to be sure, but mercifully few at that.) Of all these, perhaps the most welcome read in part as follows: "I had been away for many days and so I was quickly filling up my morning with busy tasks. . . . I spotted your column—and my day changed. . . . My mind slowed down, and life to me took on the right perspective again."

Who could ask for a kinder appreciation? But recalling the skeptic in Luke's gospel, I instantly thought, "Physician, heal thyself."

That kind letter, you see, reached me after I too had been away for many days, on a delightful visit with a West Coast friend of many decades. And like my correspondent, it seems, I behave strangely after being off somewhere, even briefly: I worry that everything must be done yesterday, because I have been neglectful.

Neglectful of what? I have been retired for years now.

But old habits die hard. And, because April is National Poetry Month, I did return to a whole series of scheduled appearances. Within ten days, I had nine such obligations, four of which involved back-to-back round trips of four hours and more.

These appearances, of course, did not constitute work. If I'm to read, the work has already been done (and it's best described anyhow as work, not labor). Likewise if I was to visit a library to speak about poetry: after some ninety such visits I needed no "preparation," but only to show up and enjoy the people I met.

The letter I mentioned, together with my own idiotic anxiety and hurry, got me to thinking about the ways in which poetry is, or should be, related to slowing down, and how such slowing down may relate to what that letter called a right perspective.

In 1991, former US Poet Laureate Mark Strand contributed an essay to the *New York Times*. It was aptly called "Slow Down for Poetry," and it indicated, better than I will here, that poetry asks us to eschew the pace of typical contemporary life, because we can't take in a poem's particular qualities at the same speed with which, via technology, we more and more receive information. We can't rush through it as we may through website pages. No, to absorb poetry, we must contemplate line, sentence, stanza, image, metaphor, and so on. We must, as a rule, re-read. We must, that is, slow down.

Last night, my wife and I had a restaurant date. We try to schedule one every week if we can. (I almost said "if

time allows.") The place we chose has a charming ambience, a professional and cordial staff, excellent food. As soon as we were seated, though, I beheld something that in our time is a commonplace. At a table near to ours sat a family of four, from whom we detected precious little conversational buzz, because for most of the meal, all its members were glued to their smart phones. Could anything short of natural disaster or someone's health crisis, I wondered, be so urgent that these people couldn't savor what was served them, and more importantly, each other's company?

As a writer, I have over and over again—sometimes, granted, at risk to practical obligations—experienced so profound a meditation on my own language and on all that it starts in my soul that I've suddenly looked at my watch and been stunned: what I'd believed mere minutes at my task turned out to be hours! I have, as the saying goes, lost all sense of time.

Now it's not that everyone needs to be a poet, not at all. Nor is poetry the only mode of entering that unclocked sphere. But it is one way.

I try hard not to moralize in these speculations, because I have plenty of defects; I am no better than the next man or woman. And yet I worry that for our culture knowledge has in fact been confused with the accumulation of data, and that we are so bound by our hell-for-leather virtual world that we miss the non-virtual. How often, for instance, have I seen kids intent on some device's screen as the car they sit in passes through the Green Mountains or along some jewel-like lake's shore? I want

to scream, LOOK UP! What shock I felt, too, on one recent occasion to hear a highly remunerated software engineer ask at just what point George Washington was U.S. president.

That engineer would have said, perhaps, and rightly, that every sort of information is now accessible with the touch of a keyboard. I won't be hypocrite enough, either, to say that I don't take advantage of that access. But information and knowledge are not identical quantities, nor are data and a vision of our world.

I'm given to quoting from my greatest predecessor as Vermont's state poet, and it seems to me the following remarks are deeply related to what I am insisting on here:

> Anyone who has achieved the least form to be sure of it, is lost to the larger excruciations. I think it must stroke faith the right way. The artist, the poet, might be expected to be the most aware of such assurance. But it is really everybody's sanity to feel it and live by it. Fortunately, too, no forms are more engrossing, gratifying, comforting, staying than those lesser ones we throw off, like vortex rings of smoke, all our individual enterprise and needing nobody's cooperation; a basket, a letter, a garden, a room, an idea, a picture, a poem.

Frost may seem to knock poetry off its putative pedestal by likening it, say, to a letter. Be that as it may, the great man's message is clear, and it is implicit, precisely, in the sentiments voiced by the maker of the letter I cited at the outset. Everybody's sanity, including my own, I agree, depends on slowing down. Poems can help if we are inclined that way.

Frost in His Letters

~

I RECENTLY COMPOSED AN ESSAY on *The Early Letters of Robert Frost* for the *Georgia Review.* In the process, any number of things occurred to me, including the fact—and I have thought on this for some time—that this sort of volume will be unavailable to future readers, who may be interested in our own day's authors, poets or otherwise. Such writers' correspondence, like my own (full disclosure), is all but exclusively electronic, and whatever its other undeniable virtues, that mode of communication lends itself poorly to the sort of artful construction everywhere obvious in the Frost book I considered.

But another thing has stuck with me, namely how deep and abiding has been the portrait of this great poet as painted by Lawrence Thompson and R.H. Winnick in their now forty-year-old three-volume biography. For reasons of their own, and rather inscrutable ones in the end, these men depicted Frost as a monster, a megalomaniac, a treacherous friend, a cruel father— on and on. Ever since, each sympathetic consideration

of the artist's life must somehow come to terms with Lawrence and Thompson's dyspathetic vision. Even the counter-efforts of so acute a student of the man's work and life as Amherst College's William Pritchard, however, seem not to prevail. The ogre image lives on.

Though the two biographers' achievement seems to me subject to severe challenge, there is no getting around the fact that it was, simply, astonishing in its abiding effect. People who have never read a full volume of Frost poems feel utterly confident in describing the man as insufferable. They may not know it, but they do so on the strength of the Thompson-Winnick enterprise.

I make no pretense of being other than a committed admirer of Frost's work, and to that extent my own take on his personality may have its own share of bias, not equal but opposite to that of the two men primarily responsible for his vilification. In any case, I came away from these delightful (and fabulously erudite) letters confirmed in my sense of the man's greatness not merely as poet but as human figure.

There can be small doubt that Frost had his character defects. In my seventy-odd years, I haven't met anyone of whom that could not be said. In a very long letter of 1915 to the African-American poet W. S. Braithwaite, Frost himself recognizes his susceptibility to the exploitative, hyper-ambitious, callous, and even misanthropic behavior with which Thompson and Winnick so effectively taxed him. Frost's written remarks are among other things a valuable retrospect on what went into his first collection, *A Boy's Will,* published in Great Britain, and

an insight into the nature of the book that made his American reputation, *North of Boston.* They also, by my lights, show how a boyish sensibility grew into an adult one.

"A Boy's Will," Frost writes to Braithwaite,

> is an expression of my life for the ten years from eighteen on when I thought I greatly preferred stocks and stones to people. The poems were written as I lived the life quite at the mercy of myself and not always happy. The arrangement in a book came much later when I could look back on the past with something like understanding.
>
> . . . I suppose the fact is that my conscious interest in people was at first no more than a technical interest in their speech—in what I used to call their sentence sounds—the sound of sense . . . I began to hang on them very young.
>
> . . . I say all this biographically to lead up to Book II (North of Boston). There came a day about ten years ago when I made the discovery that though sequestered I wasn't living without reference to other people. Right on top of that I made the discovery in doing The Death of the Hired Man that I was interested in neighbors for more than merely their tones of speech—and always had been.

To me, as I say, these are the words of a man who has grown up, and who has the wit to recognize that development, and so largely to put away childish things. They scarcely strike me at any rate as the words of an

unbridled egotist. And as we move through *The Early Letters*, we see them witnessing to the breadth and sincerity of Frost's friendships—some casual, some, like the ones with Sidney Cox, Louis Untermeyer, John Bartlett, and above all the English poet Edward Thomas, as close to those of soul mates as the poet ever had, as deep perhaps as a person could know.

By my reading, that is, Frost's letter to Braithwaite exposes his intention to suppress his purely self-serving impulses—which doubtless exist, at all events, in every human heart. But again, the Thompsonians construe this and other letters from a radically different perspective, from which each and every comment by the poet is another instance of self-promotion.

As I considered this vast collection of correspondence, one again, as in past considerations of the censure delivered by Frost's assailants, I thought of Malcolm Cowley's comment that "no complete SOB ever wrote a good sentence," because the figure presented by the Frost-as-monster portraitists seems simply out of line with the person responsible, precisely, for the plain artistry of "The Death of the Hired Man." The art somehow reveals the heart. Could Frost have written "Home Burial" if he was as stony and calculating as his bashers claim that Frost was? Could a dyed–in-the-wool misogynist (another frequent charge) have accomplished such a poem so brilliantly, or "A Servant to Servants," or "The Wild Grapes"? (That list too could be lengthily protracted.)

And the naysayers seem never to make much room for the relentless pains and crises—including illness,

madness, death, and poverty—that the Frost family as a whole endured in the years following the period chronicled in these early letters. They pay scant attention to how these circumstances may have affected the moods and behavior of a man so well attuned to the spirit's workings as Frost showed himself to be in the poems just referred to and in countless others.

Again, I would never deny that Frost's ambition was altogether enormous, as, true enough, any number of these letters indicate; and I have small doubt that such ambition could and did lead him to acts that at his best he himself would have described as shameful. But can that be the full story?

Let's consider another frequent charge: that Frost was so career-minded he neglected or, worse, stood in the way of his children. As it happens, just as I received my review copy of the *Early Letters*, my novelist friend Roberta Harold lent me something called *As Told to a Child, Stories from the Derry Notebook*. This is a collection of bedtime tales made up by Frost, and illustrated by his progeny.

In her introduction to this volume, Frost's daughter Lesley, singled out by Thompson and Winnick as having suffered especially under the evil influence of her father, writes as follows:

> After exposing me to a variety of narrative and lyric poems (some of which I quickly learned by heart) and after getting me to write brief critical essays, he never so

much as hinted that he was frequently writing poems of his own, at the table in the kitchen of our farmhouse, long after we children had gone to bed.

Somehow this picture does not jibe with the one that the maledictors present, that of a man so career-driven as to shut out every other decent concern in his life, public or private.

Indeed, Frost's letters to his children, and above all the many to Lesley, though rather more formal, to be sure, than ones a contemporary parent would likely compose, strike me always as offered with nothing but the children's good at heart, and further, though my judgment is of course subjective, they seem all but uniformly to provide worthy and well considered counsel.

For their part, the admirable editors of the volume of letters in question, Donald Sheehy, Mark Richardson, and Robert Faggen, are careful in their annotations not to engage overmuch in the whole controversy over Frost's character. They reserve their measured condemnations of Thompson, Winnick, and similar partisans to a truly superior preface and introduction. They comment as follows on the first two volumes of Thompson's study, the ones Thompson lived to complete (*Robert Frost: the Early Years* (1966) and *Robert Frost: the Years of Triumph* (1970)): Thompson "deployed an enormous body of documentary evidence gathered over twenty-five years of research in the service of an interpretive agenda that the evidence simply does not support."

The editors also make a case for their own editorial principles by comparing them to Thompson's in his shoddily assembled *Selected Letters* (1964),

> which included the following entries under "Frost, Robert Lee" in the index: "Badness,""Cowardice," "Enemies," "Fears," "Gossip," "Insanity," "Masks and Masking," "Profanity,""Resentments, and "Self-Indulgence." Absent are entries for goodness, bravery, friends, hopes, discretion, sanity, honesty, genuineness, gratitude, generosity, and restraint.

Let me leave this whole touchy subject at that, abandoning each reader to his or her judgments, which will be what they are in any case. I want to conclude, above all, by recommending the volume to which I refer, so rich and rewarding. Whether you love or hate Frost, you will find yourself stimulated, and very frequently amused (for he was a highly witty fellow), at almost every turn. That this college dropout, son of an alcoholic father and long-suffering mother, brought up in what sophisticated people still think of as the boondocks, should have turned out to be so learned, and even more, should turn out to have, from a very early age, such profound insights into the heart of poetry—well, all that strikes me as one of a handful of American literary miracles.

Morals

~

MY WIFE AND I OWN A CABIN IN MAINE. I bought it for $500 some forty years back, before we were married, because its neighborhood is spectacular. The place sits, however, in the poorest county in the northeastern U.S. Since the economic meltdown of 2008, that poverty still shows more plainly than ever: abandoned farms, houses, and even tarpaper shacks for sale, items of little value by the roadside, marked with scanty prices. On our way to the cabin in the dead of a polar vortex winter, I winced as always to pass a canted school bus next to Route 6.

I vaguely know the man who lives in the bus year-round.

During our stay, such desperation weighed on our minds, subtly chewing at our peace and coziness. I tried to solace myself by thinking I'd done some small good as president of a local land trust, whose mission is not simply to set aside forests and waters for conservation's sake but also to provide some sustainable forestry

jobs in a zone where employment of any kind is hard to come by. Still, a hellish lot of people are hungry in that county, a fair number of them breaking game laws by way of survival: while we were at our cabin, a whole family was arrested for killing a cow moose out of season. They had their reasons.

Maine is one of the three hungriest states in the nation, but Vermont is in the top ten too. Awareness of such statistics kept eating at us, perhaps especially because of the season's bitter cold, and got me to thinking about people who pass through upper New England, perhaps to ski or for some picturesque wedding, and who imagine they behold a rural Eden. Unfortunately that view is not uncommon among many who live in the North Country too. How frequently does one enter a restaurant or a B&B hereabouts and find some claim that the place recalls "a time when life was simple"?

When on earth was that? After all, the sort of poverty I'm reflecting on proved more or less commonplace in our region back in those allegedly simple times. One can find reference to it throughout the work of our first state poet, as I'll indicate directly. A time when life was simple? It wasn't back then, and for too many it's not that now. The various food banks that many of us support are more than worthy institutions; but mustn't we now and then wonder why they remain so badly needed?

Those who construe the North Country as a place of simple peace and comfort need to travel over the ridges and look on their other sides. I am no saint, no Mother Teresa, but I have witnessed some grim struggles over

there. I began as a tutor for Central Vermont Adult Basic Education, whose board I now chair, and I've seen the bitter complication of certain lives in such a capacity. Moreover, and perhaps strangely, even offensively, to some, my lifelong hunting enthusiasm, while not a matter of survival, of course, has led me into the company of many for whom it was and is. Their perspective on the North Country is a lot less quaint than the complacent one I refer to—and for understandable reasons.

A little detour: The Robert Frost Place in Franconia, New Hampshire, where the great author lived from 1915 to 1920, sponsors a resident poet every summer. In 1977, it was Robert Hass, who two decades later would be U.S. Poet Laureate. I went to visit Bob during his stay, and he repeated a story told to him by an elderly lady down the road from Frost's house. The woman had long left Franconia, but she'd been born in the village, and had spent summers helping her grandparents, who farmed the land abutting Frost's. Early in Frost's tenure, she and her grandfather were riding his wagon to town for staples when they saw the poet sitting on his porch.

"Grandpa," the little girl asked, "who's that man who bought the Heberts' farm?"

The old fellow replied, "That is the laziest, most good-for-nothing person who ever moved to Franconia. All he does is sit in that chair and write letters. Come winter, he'll be down in the village and we'll all be paying for him."

The story is amusing, but it speaks to a time—and maybe it *was* simpler in this one regard—when towns

in our part of New England were obliged to provide for citizens who could not do so for themselves. In my own memory, Vermont had Overseers of the Poor, who were charged with seeing to this. There were also poor farms, the last dying in the 1960s, where the indigent could labor for sustenance. There is a famous, early-1800s court case involving a Vermont judge who owned an African-American slave. She'd toiled for him all her working life, but when she became old and disabled, the judge felt the town should look after her. He had to recuse himself from the final Supreme Court decision, which went his way, as I recall, because he was in fact Chief Justice (simpler times, you see).

Now I despise cartoon politics, left or right, the sort of rhetoric that offers pat, blanket solutions to major social problems like the one I describe. I'm not going to point any fingers in this little essay, and Lord knows that no poetry worth its salt would ever engage in simplism either, political or otherwise. But a poem like Frost's own "An Old Man's Winter Night" offers a dark comment on cavalier notions of Emersonian self-reliance among the indigent. I haven't room to quote it here, but if you look it up, you will find the world's loneliest poem.

What poetry can do, at least, is to remind us how our morals are taxed every day, if our eyes are open. Or it can open them. No, I have no right to play saint or sage, drawn like anyone as I am to comfort and to clan, and helpless as the next person to construe just societal solutions. But poetry, or at any rate poetry as keenly attentive as our first state poet's, can remind us of an ongoing

history, which still includes too much misery and want, and of our own inclination to dismiss or rationalize it for our own benefit. We should at a minimum be asking questions of ourselves:

Love and a Question

A Stranger came to the door at eve,
 And he spoke the bridegroom fair.
He bore a green-white stick in his hand,
 And, for all burden, care.
He asked with the eyes more than the lips
 For a shelter for the night,
And he turned and looked at the road afar
 Without a window light.

The bridegroom came forth into the porch
 With, 'Let us look at the sky,
And question what of the night to be,
 Stranger, you and I.'
The woodbine leaves littered the yard,
 The woodbine berries were blue,
Autumn, yes, winter was in the wind;
 'Stranger, I wish I knew.'

Within, the bride in the dusk alone
 Bent over the open fire,
Her face rose-red with the glowing coal
 And the thought of the heart's desire.
The bridegroom looked at the weary road,
 Yet saw but her within,

And wished her heart in a case of gold
 And pinned with a silver pin.

The bridegroom thought it little to give
 A dole of bread, a purse,
A heartfelt prayer for the poor of God,
 Or for the rich a curse;
But whether or not a man was asked
 To mar the love of two
By harboring woe in the bridal house,
 T he bridegroom wished he knew.

John Engels

~

I WAS INVITED SOME TIME AGO to give a talk and reading at St. Michael's College in honor of the late Vermont poet John Engels, an annual affair. That invitation set me, scarcely for the first time since his death or even before, to thinking about how much he has meant to me—and how desperately I want people to know his wonderful work.

In my very first book, *Searching the Drowned Man*, published in 1980, I dedicated a poem to John. I was forty years old when that book saw print. Four years earlier, at what already seemed to me a rather advanced age (thirty-six) for an aspirant author, I'd been a Scholar at the Bread Loaf Writers' Conference, and John, at the *seriously* older age of forty-six, was a fellow, sidekicking a workshop with Mark Strand. After that year and until his death in 2007, John remained a cherished friend and a precious poetic model.

In '76, I remember finding him a superior poet to
many who outranked him in the Bread Loaf hierarchy.
The difference between his reputation and theirs seemed
unjust to me then, and it does now. I concede that this
view may have something to do with the fact that from
the start we two had certain interests in common: we
both loved jazz, for example; we loved to tell stories; we
loved trout fishing; and we loved Vermont (whose state
poet he should surely have been at some point during his
lifetime).

I can't legitimately claim to remember my precise
motive for dedicating the poem in question to John. In
any case, here it is:

A Dream Near Water
You walk toward the river. White flecks in your beard
 have gone;
But so has the beard. Completely. You're surprised,
Bending to cup up water, at the glossy tone

Of your skin. You notice the wave and swell
Of your arms. All the women—girls, really–
You ever adored: they seem to be wishing you well

From the opposite leafy bank. As one, they stand
In smiles, wearing the billowy loose beach suits
Of another time, breeze-riffled, extending their hands.

It's before the invention of clocks, or any chronometer.
(Amazing, what this means to time in the dream.)
So save your distinctions—*happy, sad*—for later,

For you feel no desire. You'll recall a pleasant view
And directly, the taste of water so clean you'll ache,
But not until awake, with something like sorrow.
Slim birds are fluting from the clickety reeds,
Pastels. Your children aren't a factor. Summer
Looms, as wide as ocean. This soft morning haze

Will be half the day burning off, uncountable hours
Will pass before your father sends up to your window,
Through which the dusk air puffs a scent of flowers,

His familiar whistle of greeting. He's come home
From a day trip on the lake. Later, he'll mount
The stairs to tuck you away in the violet room

Where, for a time that passes slow as an age,
You attend to tales that provoke unthinking laughter,
To your mother whose sobs are beading like dew on the
 page,

To the June frogs that wake and call to you over calm
 water.

All these years later, I offer an interpretation, both critical and memoiristic, of the poem. It's scarcely watertight, and I know as much. It's almost as if the words belonged to someone else, as in a sense they do, their composition more than thirty years old. The relatively young man who first admired Engels was in many ways different from me, from the septuagenarian who now mourns him.

Now any poem with "water" in its title would of course have seemed an apt tribute to John, precisely because of his and my craving for rivers and fly fishing. But looking at "A Dream Near Water" now, I simultaneously sigh and chuckle over what may have been its stronger urge. The poem's rather fuzzy addressee, *you,* was likely John himself, though I guess it was somehow myself as well; that protagonist hankers for youth, for that immediately post-Edenic condition in which, as Milton puts it, the "world is all before" us. If I thought myself somewhat antique for a beginning poet, I found inspiration and kinship in the suave and moving Engels, who was in his mid-forties, old indeed, as I say, for the rank of mere Fellow at that famous conference.

There is a subtext of honesty and even of realism in the Utopian vision of the poem, however, despite its evocation of a world so open and full of potentialities that he and I might over time inscribe ourselves upon it. For example, both of us had experienced the influence, for good *and* ill, of ultra-powerful parents, a mother in my case, a father in his. It may not show overtly, but

under the surface of "A Dream Near Water" was my own reliance, too, on a father whose mildness was a buffer against the rigors I felt exerted upon me by his wife, one actually inclined more toward command than to shedding of tears. And yet, on the "opposite leafy bank," there is a flicker of hope, some signal that a redemption, even if momentary and partial, may after all be available.

It seems to me now that at the heart of my love both for John and for his poems was precisely his capacity to signal assurance, even solace, at the same time as he masterfully registered pain and regret, his writing's joy simultaneous with its darker pathos. (Consider this exemplary title poem from one of his colletions: "Cardinals in the Ice Age.")

John Engels was his life's own protagonist, of course, one who, no matter that like all of us he was a fallen creature, persistently reminded us of all the good motives for living this full, vexed, trying, funny, and tragic life we've been given.

I'll close simply by quoting a work by his hand, having bid *ave atque vale* to a stout heart, to a dear soul who outlives himself in my dreams near water—or anywhere.

Damp Rot

Water sheets on the old stone of the cellar walls,
trickles out over the floor into little deltas of mud,
worse every year, so that now I can see daylight
at the footings, and upstairs the floors sometimes

tremble and the clothes go damp in the closets. And
 sometimes
I think the whole place is about to come down, and
have begun

to dream at night of moving, unaccountably sad
to think of leaving this house which has possessed me
 now
for eighteen years, in which one of us has died
and two been born, for all its elegance of detail most
everything
not right in it, or long gone bad, nothing
ever done which should have been, one hundred years
and more of water rancid in the cellars, moldings
never finished or else mitred crookedly, all

the small and growing energies of dirt and rot
wherever we care to look, whenever we do. And we do.
But I dream also of the pine grove of my planting,
which I know I love and which is the green truth
of this place: in one day ten years ago
I dug fourteen small trees, wrapped the roots
in burlap, dragged them down from the top ridge
of the hill, spaced them carefully, watered
them each day for one whole season. Now

they are twenty feet high, thick roots
already at the cellar wall, vigorous and loud
even in little winds, only the hemlock

mournful and reluctant to do much in the way
of increasing itself. But it is clear
that if I do not freely leave this place,
it will leave me—though, as Ray Reynolds says,
digging at a powdery floor joist with his knife,
there may be more here than I think, better
than a two-by-six at least; and his blade slides
two inches in and stops at what he calls
the *heartwood*, meaning, as I take it, at the wood
which has not yet given way.

Bikes

~

MY WIFE AND I ARE JUST BACK from a week and some in the Netherlands, visiting our youngest daughter, who was on academic exchange there. We spent most of our time in Amsterdam, with time out for a couple of glorious days bicycling on the island of Texel.

Bicycles are everywhere in that country, which partly explains, no doubt, why any unfit person one meets there is probably a tourist, and why, for a big city, Amsterdam is so stunningly quiet. As we pedaled from place to place within the metropolis, I couldn't help thinking how much more livable our own big towns would be—not to mention how much "greener"—if they were equally bike-friendly. And it frankly depressed me to imagine the shouting down of such an idea, were it proposed in most of those towns.

Bicycles for commuting? How Third World.

Of course the Netherlands is anything but that. We Americans are so schooled in the We're-Number-One

mentality that many of us instinctively impute inferiority to all places that happen to lie outside our borders. Yes, the Dutch do pay a lot of taxes, a word that not even liberal politicians dare speak in our current, constrictive moment. At the same time, their poverty rate is a mere fraction of ours; the gap between upper and lower financial strata is an immensely thinner one; there is little evidence of homelessness in the Dutch streets; a comprehensive health care system ensures that catastrophic illness will not bankrupt a family, as it can so easily do here; and their infrastructure makes ours, crumbling under our very noses, appear the Third World example. But.

But the inclination of self-styled sophisticates in the *anti*-We're-Number-One direction is often just as misguided. A monumental blessing of having been a writer and/or academic for four decades is that I've enjoyed very extensive travel experience—from which I have concluded that to grow instantly infatuated with this or the other "foreign" society is facile and wrong-headed. It's a silly mistake to imagine altering all we stand for in order to ape that society's virtues. (Not that reasonable people shouldn't, for example, be appalled by the US rate of infant mortality, on a level with Jordan's.)

One can draw no useful conclusions on the basis of a vacation, or even a few years of residency. Indeed, I'm sure it takes a lifetime to understand the nuances, grim and bright, of any culture, and to think otherwise is to engage in cartoon sociology. Our own Dutch stay was briefer than brief, but with each passing day, this conviction recurred to me with increasing force. At seventy,

even if I wished to, I wouldn't have enough time left on earth to get a true sense of what we (wrongly) call Holland. For starters, I'd have to learn the language at least as well as most Dutch know English.

One morning, I got out of bed earlier than my wife, wanting some time to polish a lecture I'd deliver in Brattleboro on return to the States. For whatever reason, though, I found my mind wandering off task.

Here I was, shaping up a talk I'd been asked to give on the premise that the state poet must "know a lot about poetry." Well, yes, I suppose I do know a lot about poetry. Some of it.

But how much, I mused, do I know about *Dutch* poetry? Precious little. In fact, the only Netherlands poet I know personally (and this mostly by way of correspondence) is Hans van der Waarsenburg, whom I met at an international PEN conference a decade ago. His English is every bit as good as my own, so I am inclined—far more than is usual for me—to trust the poet's translator, Hans himself having done the job in the poem I cite below.

This is a poem that captures my attention not only for its salty humor, its incisive perception, and its economy, but also, the writer being just my age, for its dead-on evocation of rock 'n' roll's explosion onto the scene in the fifties, and of the fabulously outraged responses of our elders . . . which anticipated our own responses to the music our own kids seem to favor. In short, amid the nostalgia and the wit, there's a faint smirk at hypocrisy in every human quarter.

Early that morning in an Amsterdam hotel, as I remembered "Bill Haley in Maastricht," I wondered: if there's work of this quality in one Dutch poet, what might be the general case for that country's poetry? I am not equipped to say, will never be.

I refer to poetry here simply because it's what I have known for a great portion of my life; but I hope, with rightful humility, that my thoughts may extend to other modes of human behavior. We may or may not be artists, but we all must be citizens. As such, should we not bear in mind that whatever we think we "know a lot about" excludes the experiences of countless, unnamable others?

Bill Haley in Maastricht

What had not assailed the ears!
The dulcet tones of Mantovani, Helmut Zacharias
Sugary syrup of the lowest seaside sort. Incestuous
Family gathering. Hurrah for raised skirts

The grasping, groping hands. The uncles
Heated, randy with lager and provocative drops
Of gin. Catholic orgy, suddenly smothered
By Bill Haley and his whirling Comets.

Their sound burst into the room like
Exploding shells. As if the devil himself had
Appeared. As if the end of time had come
And the curtains were torn to shreds.

Never were heads shaken so firmly and was
Spittle blown to all points of the compass.
One of those days, filled with dire curses,
Sleepless nights and snoring daydreams.

~

Time languishes in vinyl, like sad banknotes.
Yes, the spit curl stuck to his forehead. Yes,
Blue jeans blew their top. Fat-bellied
Rock 'n' Roll, with Moluccans swinging and

The bass player bestriding his instrument.
Pints were downed, disappearing in the
Hollows of everyone's past. Bill Haley
In Maastricht. Late Sunday service, brylcream

On old heads. Their fathers, already dead,
Had to be reburied. Steam rising
Once again. I turned my back on those fragile
Days: SHAKE RATTLE 'N' ROLL.

A Centennial

⁓

F ROM MAY 5 THROUGH THE 11, 2014, I was, far
from for the first time, in the gorgeous lakeside
town of Bled, Slovenia, participating in a PEN
conference. PEN champions the abolition of censorship
and the freeing of literary-political prisoners, of which
there are twenty-eight in Cuba, say, and an uncountable
number in China. Most of the proceedings, then, involve
political strategizing.

There was, as always, another dimension of this con-
ference too. This year marks the one-hundredth anniver-
sary of World War I, and our theme was "The Great War
and Modern Literature." As the American representative,
I'd been urged to speak of our own nation's response to
that calamity.

Here I copy a version of my comments, but first the
lucky back story of why I'm a participant.

In 2001, I was teaching in Lugano, Switzerland. A dip-
lomat friend, whom our family had met ten years before
when I held a Fulbright Fellowship in Hungary, invited
us to stay at their Budapest home over Easter break and

I'd give a tenth anniversary reading. The stay was delightful, and afterwards, our host said he'd spread the word to fellow diplomats that I would happily lecture or read elsewhere. I did so in several cities, including Ljubljana, the Slovene capital.

I joke that Slovenia is where right-acting poets go after death. I was in its national press, on its national TV, and most gratifying, on its public radio's *daily* poetry program.

After the show, I had lunch with my excellent interviewer, Marjan Strojan. I learned then that he was not only an eminent poet himself but also the foremost Slovene translator of English poetry, having managed such modest projects as *The Canterbury Tales, Paradise Lost,* and *Beowulf.* But he claimed his greatest challenge to have been the work of Robert Frost: Marjan seeks form-true translation to the extent possible, and even more important, translation that *sounds* as close to the original as it can. The challenge lay in spoken Slovenian's being all but devoid of Frost's signature iambic foot. For all that, Marjan had managed fifty poems in half as many years, and they'd soon be published in book form.

My new friend and I stayed in touch, and in due course I got a sad note from him. His publisher had botched the protocol to secure international rights to Frost's canon, and Frost's American publisher, Henry Holt, would exact a prohibitive permissions fee for any print run that exceeded 200.

By pure chance, Frost's literary executor is Peter Gilbert, my friend and former student, now director of

the Vermont Humanities Council. So I forwarded this dejected email to him, along with my opinion that every single living Slovenian could buy Marjan's book of translations without the least effect on Holt's bottom line. Peter arranged the permission for a song.

For me this involved a quick email; for Marjan it redeemed a quarter-century's work. In gratitude, he began to invite me back to all manner of literary events. Each time, he'd translate some of my poems, and in 2006 a selection of them appeared in print over there. Best of all, over time the translator has become one of my dearest friends.*

Now my remarks, abridged, for the PEN conference.

The Great War and the Death of Abstract Language

Ten decades ago, US president Woodrow Wilson argued to a doubtful American populace that the country's entry into war would "make the world safe for democracy." Such idealistic rhetoric soon measured itself against brute fact: hundreds of thousands of war casualties and maimings.

The following, written by e.e. cummings after his Great War experience as an ambulance driver, makes much of such dissonance. It ironically echoes a tune that nearly became our national anthem. We all know that the song begins "My country, 'tis of Thee,/ Sweet land of liberty," and goes on to salute the "Land where my

*In 2015, Autumn Hill Books in Indiana, an excellent house specializing in eastern European authors, has published *Dales and Hollows,* a selection of Strojan's original poetry, in this country.

fathers died,/ Land of the pilgrims' pride . . ." But hear the poet's twist:

next to of course god america i
love you land of the pilgrims' and so forth oh
say can you see by the dawn's early my
country 'tis of centuries come and go
and are no more what of it we should worry
in every language even deafanddumb
thy sons acclaim your glorious name by gorry
by jingo by gee by gosh by gum
why talk of beauty what could be more beaut-
iful than these heroic happy dead
who rushed like lions to the roaring slaughter
they did not stop to think they died instead
then shall the voice of liberty be mute?

He spoke. And drank rapidly a glass of water.

Artists have always been suspicious of conventional pieties, but the Great War deeply enhanced that suspicion. Cummings's own anti-war suspicions were vocal enough to earn him a military incarceration and, eventually, to prompt a compelling novel, *The Enormous Room*. In the poem above, the clash of pietistic slogan with grim factuality is patent, and its demagogic protagonist seems to know it: he races through his address, reluctant to use his own jingoistic shibboleths. Unlike the hymn he quotes in part, the speaker avoids mentioning *pride,* for instance, and even if he makes an obligatory reference

to *God*, as American politicians still seem obliged to do, he's disinclined to say that his "country 'tis of *Thee*." At the end, we read, "He spoke. And drank rapidly a glass of water," as though he sought to wash the formulaic blather out of his mouth.

Cummings won't ennoble rhetorical convention as a mark of patriotism, any more than he will consider poetic convention like the sonnet, which he at once adopts and mockingly subverts in this poem, as one of art. Even conventions of grammar and punctuation seem to offend him. No bromide, no propriety whatever—right, left, center, religious, atheistic—is simply to be accepted at face value.

There are examples of such skepticism and resistance throughout the work of American artists of the Great War. Given time constraints, I'll refer only to Ernest Hemingway, another ambulance driver. He raises themes akin to Cummings's, most famously in *The Sun Also Rises,* but really throughout his earlier work. One of his stories, "The Gambler, the Nun, and the Radio," written in the aftermath of the first global war, is exemplary.

The plot unfolds in a Catholic hospital, and involves a Mexican gambler, Cayetano, who has been shot in a small Montana town; a nun who aspires to be a saint; and Mr. Frazer, a writer recovering from a horseback accident, who constantly listens to his radio.

The nun invites three Mexican musicians to perform for Cayetano. One of them suggests that religion is the opium of the people, dulling them to their ignorance. After Frazer hears that opinion, he reflects as follows:

Religion is the opium of the people. He believed that, that dyspeptic little joint-keeper. Yes, and music is the opium of the people. Old mount-to-the-head hadn't thought of that. And now economics is the opium of the people; along with patriotism the opium of the people in Italy and Germany. What about sexual intercourse; was that an opium of the people? Of some of the people. Of some of the best of the people. But drink was a sovereign opium of the people, oh, an excellent opium. Although some prefer the radio, another opium of the people, a cheap one he had just been using. Along with these went gambling, an opium of the people if there ever was one, one of the oldest. Ambition was another, an opium of the people, along with a belief in any new form of government. What you wanted was the minimum of government, always less government. Liberty, what we believed in, now the name of a MacFadden publication.

Though Frazer makes no direct reference to the Great War, its effects show themselves here: like Cummings, he stresses the emptiness of abstractions like *Liberty*. And yet, half-addled by drugs and drink and pain, he speaks as follows:

> "Listen," Mr. Frazer said to the nurse when she came. "Get that little thin Mexican in here, will you, please?"
> "How do you like it?" the Mexican said at the door.
> "Very much."
> "It is a historic tune," the Mexican said. "It is the tune of the real revolution."

"Listen," said Mr. Frazer. "Why should the people be operated on without an anæsthetic?"

"I do not understand."

"Why are not all the opiums of the people good? What do you want to do with the people?"

"They should be rescued from ignorance."

"Don't talk nonsense. Education is an opium of the people. You ought to know that. You've had a little."

"You do not believe in education?"

"No," said Mr. Frazer. "In knowledge, yes. "

In distinguishing education from knowledge, I believe Hemingway smells danger in thought removed from tangible, empirical reference. Such thought is, so to speak, *disembodied* speech; it's abstract in the Latin sense of "drawn away." The wounded and dying are unlikely to recite *dulce et decorum est pro patria mori*. The anodynes we propose to soothe us in a world as cruel as late history has proven—perhaps all are empty; but the broad political ones, which have so deceived and wounded "the people," are downright disastrous. We all may deceive ourselves; but let us at least be modest in our self-deceptions.

The constitutional skepticism that I mentioned at the outset has by our time solidified itself among American artists; but, tragically, it has not spread among the truly powerful. I can think of no U.S. poet of my acquaintance, for instance, who endorsed George W. Bush's unconscionable 2003 misadventure, code-named—what else?—*Iraqi Freedom*. And yet that murderous and foolish campaign went forward. Bush spoke of an "axis of evil."

He had not, one assumes, ever encountered the counsel of Ezra Pound (before Pound himself went politically insane): *Go in fear of abstractions.*

Yes, I wince in my own time to hear billowy, abstract rhetoric in the mouths of politicians. *Iraqi Freedom* indeed. I can read the news and see what that freedom amounts to even now. I wish, however, that the problem were a partisan one. Today, however, with a supposedly liberal administration in office, one often hears from high places terms like *human dignity*—even as our drones wipe out untold hundreds of invisible lives.

That last example is germane. Our abstractions, our disembodiments, can so easily lead us to dehumanization . . . especially, I believe, in a virtual world. Assisted by technology, our power-brokers can all too easily divorce themselves from Hemingway's brand of "knowledge," even to the point of forgetting that the enemy dead, civilian and "terrorist" alike, were ever living, breathing people.

Let me here make a leap to consider some ramifications of all this for the writer. Since the advent of so-called deconstruction to literary study, a parallel danger emerges, at least in my opinion. That so-called literary theory should have stressed the inevitable disjunction between what we always thought was *signification* and its intended object; that it should have found language to be an unavoidable artifice: these were perhaps important propositions, and surely ratified those suspicions that artists have always held of official language. Theory may have helped discredit propaganda. But if we follow many

of its premises to their furthest conclusions, every ideal becomes at worst a lie and at best a distortion. If that be the case, then there can be no solid reason for honorable thought or activity. "It is easy to be brilliant if you do not believe in anything," as Goethe said. If there is no such thing as truth, how may we censure students who go on to join America's corporate elite?

Mark Edmundsen, a maverick professor at the University of Virginia, puts the matter thus:

> If the business of education as de-idealization had ended with the revelations about de Man's wartime anti-Semitism or Derrida's death, then all this would be semi-ancient history. But it's not over. Universities made a turn toward the de-Bunkers, and they've not turned back. Scholars don't take ideals too seriously; academics remain pretty much in the de-divinization business, which is the business of deflating or attacking ideals. Few professors in my field, literature, believe that they can distinguish rigorously between pop-culture flotsam and the works of Milton. Few of them know how to mount an argument that values Wyatt's poetry over a video game. Few believe that reading the best that has been thought and said can give a young person something to live for and teach him or her how to live.

So where, as humanists, can we stand? Have we no choice beside empty, even ruinous, Wilsonian idealism on the one hand and a skepticism so deep on the other as to amount, essentially, to mere cynicism? As so often,

I think, it is the practitioners of our art rather than its
critics and scholars who may show us a way. Let me close
with a poem by Robert Hass, a former poet laureate of
my country:

Meditation at Lagunitas

All the new thinking is about loss.
In this it resembles all the old thinking.
The idea, for example, that each particular erases
the luminous clarity of a general idea. That the clown-
faced woodpecker probing the dead sculpted trunk
of that black birch is, by his presence,
some tragic falling off from a first world
of undivided light. Or the other notion that,
because there is in this world no one thing
to which the bramble of *blackberry* corresponds,
a word is elegy to what it signifies.
We talked about it late last night and in the voice
of my friend, there was a thin wire of grief, a tone
almost querulous. After a while I understood that,
talking this way, everything dissolves: *justice,*
pine, hair, woman, you and *I.* There was a woman
I made love to and I remembered how, holding
her small shoulders in my hands sometimes,
I felt a violent wonder at her presence
like a thirst for salt, for my childhood river
with its island willows, silly music from the pleasure
 boat,

muddy places where we caught the little orange-silver
 fish
called *pumpkinseed*. It hardly had to do with her.
Longing, we say, because desire is full
of endless distances. I must have been the same to her.
But I remember so much, the way her hands dismantled
 bread,
the thing her father said that hurt her, what
she dreamed. There are moments when the body is as
 numinous
as words, days that are the good flesh continuing.
Such tenderness, those afternoons and evenings,
 saying *blackberry, blackberry, blackberry.*

I believe that, as writers and thinkers and simple cit-
izens, we must hold the feet of our powerful to the fire.
We must demand that their abstractions be tethered to
what Eliot called their objective correlatives, that they be
grounded in the flesh-and-blood realities not only of their
own constituencies but also of the world's citizenry, that
they be founded on a Hemingwayesque "knowledge."

As Hass's poem implies, there may be no way for
language to get at ultimate truths. But let us speak of
what we *can* know; let us speak of provisional truths. The
slipperiness of language, so ably demonstrated by the
deconstructionists and their successors, ought not lead us
to nihilism. Hass's poem is instructive, urging us, rather,
to humility—which, as I'm fond of repeating, never hurt
anyone.

The Point of Poetry:
Another PEN Conference

~

IN 2016, on attending the annual meeting of PEN in Slovenia for the eighth time, I was among the presenters who were asked to address the migrant (and immigrant) crisis that faces the West. As I considered what I'd say, I found myself reflecting on what strikes me as a disturbing moment in American political history. Here were my reflections.

The citizens of my nation, which I do love, may sometimes fall into the belief that our land has an *exclusive* hold on virtue; nowadays, some also find that the ever so slightly left-of-center inclinations of Barack Obama have threatened the country with ruin, moral and otherwise. I admit this strikes me as nonsense.

The U.S. still has a number of virtues, and high among them, at least until lately, has been its receptiveness to immigration. This seems apt, of course, in that the only Americans who can claim to be truly indigenous are our so-called Indians. Though I am no social scientist, I

would urge, in fact, that some other assets that America has historically displayed—improvisatory agility, inventiveness, relative disregard for social station—owe themselves to the rich variety of cultures we encompass.

There has never been a single, definable American culture. For some, this is an impediment: our lack of monarchy, aristocracy, and established religion famously drove novelist Henry James, for example, to Europe; but for others, including me, there is a hybridized glory in our most significant cultural achievments—like jazz, tap, or hip-hop dancing, and even, though I haven't space to linger on this, most of our greatest literature.* And that glory is at least partly accounted for by the multivalency of our cultural life.

It therefore greatly pains me that a nation of immigrants should now seek to slam the door against all manner of prospective newcomers. How, one wonders, can someone named O'Malley, or Zukofsky, or LaSalle, or Belli, or Feinstein, or for that matter Trump—how can any of these insist on excluding people named Hernandez or Said? For a US citizen to demonize whole categories of people (Syrian, Central American, Mexican, what have you?) smacks disturbingly of fascistical logic. I have the dreadful suspicion that my country is sliding toward the sort of thought that ushered in the Holocaust: namely, that if things are going ill in my country, then it must be the fault of some group disloyal to its national character.

*See "Democracy and the Demotic" in my A Hundred Himalayas (Univ. Of Michigan Press, 2012.

America's current socio-economic problems are legion, yes, but many angry people are now blaming them on some of the poorest and most defenseless people ever to have sought refuge on our shores. Why such citizens should hold these struggling souls accountable for their woes, rather than faulting the fabulously wealthy, who, by virtue of brute economic power, have clearly been far more responsible for those woes than any other faction— well, that's beyond me. Even more absurd is their imagining a Messiah in Donald Trump, the very personification of extravagant wealth.

Even apart from the moral issues connected to it, there are certain indisputable contradictions in our newfound exclusiveness: while so much talk is of the crime and terrorism that will accompany certain categories of immigrants, an American's chances of coming to mortal harm at the hands of one of his or her native-born, gun-toting compatriots are literally five thousand times greater than of dying at the hands of the people we are being told to curse. One also hears that illegal aliens are taxing our social service capacities and are thus a mighty burden on American taxpayers. So far as I know, there is no credible study to ratify any such claim; what *is* clear is that, without immigrant labor, the cost of many American products would soar so astronomically as truly to hurt the taxpayer. Even here in Vermont, the dairy industry would likely founder without Latin-American labor; the prices of fruits and vegetables grown in places like Florida or California, to use a more dramatic example, would

rapidly rise beyond the reach of all but those same ultra-wealthy Americans.

But for the moment, needless to say, it is Muslim immigrants who have become our whipping boys, no matter the sad irony that the US has killed many, many more Middle and Near Easterners with our ill-considered wars and our drone attacks than citizens of ours have been killed by Muslims of whatever sort, including terrorists. And yet . . .

And yet, having allowed all this, I do at the same time harbor some contrarian reflections on the issue we'll be discussing in Slovenia. The program description suggests, for instance, that "we need not repeat the hopes that so-called normal Muslims, those living in Europe and North America and already adjusted to Western standards, can calm the terrorists, although these fighters of the Caliphate represent only a small minority of the Muslim community." Really? Have I misssed some reason not to repeat those hopes? I confess to disappointment in prominent Muslim leaders' abidingly tepid condemnations, at home and abroad, of extremist violence. One can comprehend a concern for their own personal safety, and I don't mean to sound sanctmonious; I'm not sure how I myself would behave in their positions. But such worries never deterred the likes of Martin Luther King.

The program description also asserts that "Islamist terrorism has its source in a deep and fundamental rage against the West and its continuing exploitative

tendencies in the Near and Middle East, as well as its pervasive belief in the superiority of Western civilisation." Well, western exploitations and depredations in the Middle East are undeniable, and they surely do have something to do with the violence we are witnessing; and yet the planners and perpetrators of the events of September 11, 2001, of each of the more recent attacks on US soil, and of the Paris massacre seem all in fact to have been quite well-heeled and well-educated; indeed, quite a number have benefitted greatly from the abundance of the Western world. What I'm stressing, then, is that their motives appear to have been far less political than religious, or, more accurately, that their politics appear to have been determined by religious fundamentalism, as unbending in its contemporary radical-Islamic avatar as it was among militant Christians during the Crusades. The Caliphate, in a word, insists upon the superiority of *its* own culture. From my perspective, the mere fact that we, Westerners for the most part, will be able to have such an open conversation as the one I look forward to today—well, that may not be an automatic proof of relative superiority, but at this stage in my life it will do until some better proof comes along.

I should admit, however, that to play historian or social scientist takes me out of my depth. Let me turn, therefore, to some matters about which I do know a bit. Our program asks, "What can we, as writers and intellectuals, contribute to this relationship, that must grow into dialogue?" I am all for dialogue, and am far from

thinking it impossible with all Islamic people, a number of whom I include among my friends. Frankly, however, I think we live in a fairy tale world if we imagine the likes of the Islamic State, Al Qaeda, Al Shabaab, or Bokol Haram to be the least interested in dialogue. Their views of the true, good, and beautiful are, from what I can tell, absolute and non-negotiable.

Yet we are further asked, "What role must literature and culture play in resolving the conflict between Middle Eaterner and Westerner?" Most of us are lucky enough not to live in a system such as the old USSR's, say, in which—as Joseph Brosdsky once said in a journal I edited—merely to describe a flower accurately felt like a political act. But in much of the West, and certainly in the U.S., we face a subtler difficulty: namely that neither the authorities nor the public at large is likely to be swayed one way or another by anything like fiction or poetry, simply because those arts go largely unnoticed. To that extent, our better writing strategies likely involve newspapers or, more accurately in our day, social media, as opposed to the so-called creative arts.

But even online activism, to name it that, proves problematic, for at least two reasons. The first is that social media find Einstein in the same house as the village imbecile: thus, if two disparate accounts of the same thing are broadcast, there is no determining which will strike a broad readership as more compelling. In the US, this was exemplified by the idiotic controversy over President Obama's birthplace. Those who chose to label

him a Kenyan were simply not to be dissuaded by indisputable proof of his birth in Hawaii. The social media's second great liability is that, just as oppressed parties may use them, so may their oppressors, a sad fact illustrated by the ill-starred Arab Spring and by frequent manipulations of information in China, for instance.

So it may be that more direct political activism—street demonstrations, more vigorous support of candidates we believe in, and so on—are the likeliest avenues to such success as we may find.

But let us imagine a literature that *was* an effective tool of change. My surmise is that, like socialist realism, it would, *qua* writing, be bad or tepid in any case, simply because art founded primarily on an aprioristic agenda is usually doomed to inferiority in my view.

All this may sound as though I urge political or social nonchalance upon the artist, urge him or her to be a little Nero as Rome burns. Not at all. In fact, exactly the contrary. Any poet who stayed innocent of the great migrant crisis would be no poet at all. An artist must be as open as possible to all manner of observation, and must be jealous of those observatory powers, because the threats to them are myriad. To allow that openness to be usurped by *anything*—even the noblest political or moral conviction—is by my lights suicidal.

Here is a remark, which resonates with me, by my dear friend, poet Fleda Brown: "I've long since quit worrying about whether writing itself is a worthy use of my life. Whether it is or isn't doesn't change my inclination to do

it. Anyway, I'm positive that it matters, words themselves being small bulbs buried under the soil, small grenades."

I hope that Fleda is right, but in any case, I know that a willful effort to make my poems "political" or "relevant" will serve no one: not me, not my reader, and not any cause I subscribe to, including a sane and compassionate attitude toward those disrupted by violence, along with the development of a non-hysterical stance toward terrorism.

The only thing I really know to do is to beat at my keyboard. If what results is an explosion, I must accept that. If I am moved by a bloom or a bird or the birth of a grandchild, these are what I need to bring forth. The point is, we writers need to sustain belief in our own voices, and in their autonomy—not to the point of perversity or narcissism, but right up to those points. If we allow our voices to be controlled by dogma, even virtuous dogma (if there be such a thing), we might as well be writing advertisements or propaganda. We need to believe that our sincerest testimonies matter, even if we cannot define how that may be in any definitive way. We need to agree with American poet William Carlos William's assertion that

It is difficult
 to get the news from poems
 yet men die miserably every day
 for lack
of what is found there.

Choosing My Successor

~

O N THE 28TH OF MAY, 2015, I visited the Vermont Arts Council headquarters, where, with a group of peers, the process of choosing the next state poet began. I cannot, of course, comment on the proceedings, but I can indulge in some generalities, all of them connected to my somewhat melancholy recognition that this intriguing ride will soon be over for me.

Let me first applaud the intelligence, dedication, and good humor of the Arts Council staff, from director Alex Aldrich and program director Michele Bailey to everyone with whom I have dealt in that organization. Their very presence makes me proud to be a Vermonter, to live in a state where the arts play such a vital role not only in our economy but also in our daily lives. The Council's initiative and responsiveness have more to do with all that than many may realize.

The same can emphatically be said of my fellows on the committee, each so obviously committed to getting

this thing right, and taking the time necessary to achieve that end.

And yet, to speak again as a Vermont chauvinist, there surely will be no indisputably right choice. As I looked over the list of nominees, most of whom I know at least slightly, I was thrilled that our tiny state is home to so many gifted artists—and dismayed that we'll be able to choose only one.

Virtually all of these authors were around at the time of my own appointment, which makes me surprised all over again that I should have been chosen in 2011—and humbled to know that I could scarcely have argued with any number of other selections. I will participate in the final vote with a mixture of satisfaction and frustration. With no false modesty, I can say that every nominee is him- or herself a Poet Laureate in some measure, for it is our collective effort to say things that are hard to say is what keeps this cherished art alive here and elsewhere. After my time as state poet, I will never again view a poem of my own as other than collaborative.

Speaking of collaboration, I'd never have dreamed that I would write text for the state's first Cartoonist Laureate, the brilliant James Kochalka. We have just completed our third project. The Vermont Contemporary Music ensemble, having asked five of the state's composers to write pieces in response to work of mine, performed two luminous concerts as a result. The fabulous young Philadelphia composer Joseph Hallman set my "Suite in Mudtime" to music performed by soprano and string quartet (in this case Vermont's own 802 Quartet) at the

Vermont College of Fine Arts. At the moment, James and I will be joined by further collaborators, the Vermont Contemporary Music Ensemble again, and again too, Joseph Hallman: ours will be a multi-media—music, text, and drawing—presentation. Stay tuned.

And of course, still speaking of collaboration, whatever my contribution to poetry's health in Vermont may have been, it was merely an adjunct to the contributions not only of the great Mr. Frost but also of the poets appointed after the position was reinstated by Governor Kunin in 1988: Galway Kinnell, Louise Gluck, Grace Paley, Ellen Bryant Voigt, and Ruth Stone. That I should be part of that lineage frankly astounds me.

Yes, I feel lucky. And even more, I feel blessed. If I was surprised by the appointment, after these four years, I am scarcely surprised by how much I regret its ending. So I have been in retrospective mode for a spell now, thinking about all the other benefits—and I simply can't name each one—that I have experienced in this handful of years.

One is the wit I have enjoyed. The first instance, in fact, transpired in-house while I was still on the phone with Alex Aldrich, who had called with the news. I put the telephone to my chest and whispered "I'm the Poet Laureate!" My youngest daughter, still living at home in 2011, corrected me: "It's pronounced *low-rate*." But I have savored the funny remarks I have encountered at the community libraries, 115 of them, where I have given presentations on poetry. The proceedings at the three

Montpelier spelling bees at which I have been the pro-
nouncer and emcee have at times been downright hilari-
ous and unfailingly delightful. I could go on.

There is likewise the cordiality I have experienced at
virtually every stop. (The one and only exception was
an unhappy and unpleasant woman in the west of the
state who actually interrupted my reading of a poem
by standing up and averring, "That's not poetry!" Her
friends, however, quickly shushed her.)

Librarians are heroes of mine anyhow, from excel-
lent state librarian Martha Reid to all the librarians, in
places tiny and grand and in between, in Vermont: to see
the care each took with making these events successful
enhanced my feelings in this regard, as did the welcome
library patrons inevitably extended.

I was regaled with all manner of thank you gifts, from
home-baked pies to chocolates to countless mugs (which
for the most part I traitorously transported to our Maine
cabin in the woods) to precious books to—perhaps my
favorite—a salt dish carved from invasive buckthorn by
one of the artisans at Bob and Rebecca Cummings's won-
derful Center for the Expressive Arts in Montgomery.

There were several instances of pathos as well, chief of
which was a woman's giving me a memorial card to her
son, dead far too young, with an excerpt of my writing as
its inscription. I trust she understood my tears.

But as I suspected would be the case when I decided
on community libraries as my venues of choice, I was
most taken by the intelligence of so-called "average" men

and women in the crowds. I'm an Ivy League brat, but I learned well before I got to college that that league had no corner on brains and/or creativity. There's a lot of smart people out there, whatever the nature of their formal education.

I met an inexcusably young man in Randolph who read my poems more penetratingly than I could ever do myself. As I have mentioned, I came upon a dairy farmer way up on the Quebec border who could recite every single poem in Robert Frost's "Mountain Interval."Again, I could extend my catalog until I ran out of space. Suffice it to say that what I valued most was how these non-specialists instinctively knew what the important questions were, and how they asked them not, as is too often the case in academic contexts, just to show how much they already knew themselves but in fact to elicit such information as I had means to offer.

And the important questions were and are often the most basic: who's talking? to whom" where are we? why choose form X rather than form Y? If my poems couldn't answer those questions, I suspected they needed further work (which quite a number of them got).

As I went on in my tenure, I came to leave more and more time for the Q & A portion, because I was most interested in and most instructed by that portion. To all of you who so brightly participated, my profoundest thanks.

Finally, I am grateful to the editors of the newspapers in which my columns were published for four years. They

tolerated my opinions, and in many cases helped me to make them clearer. And to those who have contacted me, either in letters to the editor (again, one exception, but why dwell on that?) or personally, my thanks too. You have both encouraged me and kept me as honest as I know how to be.

Laureates

~

IN ONE OF HIS PENETRATING ESSAYS, W. H. Auden suggests that among other things poetry should take utterly complex matters and render them in language precise enough to make them apprehensible. As I have suggested before, too many of our poets nowadays, in my opinion, seem to have this exactly backwards.

I have reasons to begin my final column as Vermont poet laureate on these notes. For starters, my friend and one of my predecessors as state poet, Ellen Bryant Voigt, has lately received a Macarthur "genius" Fellowship, and her work exemplifies the values I've tried to promote during my tenure.

At each of those hundred-plus community libraries I visited, I applauded poems whose virtues, like Ellen's, include memorable language, an acute ear, formal aptness and, yes, accessibility without reductiveness. Ms. Voigt is deep indeed in all these respects; she never needs to feign depth. It is genuine and genuinely there in her verse.

I suspect Ellen would agree that no writer can be confident in his or her lifetime of having genius, but from the first time I encountered Ellen's poetry forty years ago, it seemed that if any of my contemporaries had that quality, she was one of them. An earlier work that especially stunned me was *Kyrie,* a book-length sonnet sequence that deals with the lives of people confronted by the horrific influenza epidemic, which was contemporaneous with and, astonishingly, even more deadly than the First World War. *Kyrie* was well reviewed when it appeared twenty years back, but it still seems to me a neglected book of poetry, though to say as much sounds all but redundant. I urge you to seek it out (though you won't be disappointed by any Voigt collection you choose).

Here's an older poem by her hand.

Lesson

Whenever my mother, who taught
small children forty years,
already knew the answer.
"Would you like to" meant
you would. "Shall we" was
another, and "Don't you think."
As in "Don't you think
it's time you cut your hair."

So when, in the bare room,
in the strict bed, she said,

"You want to see?" her hands
were busy at her neckline,
untying the robe, not looking
down at it, stitches
bristling where the breast
had been, but straight at me.

I did what I always did:
not weep --she never wept--
and made my face a kindly
whitewashed wall, so she
could write, again, whatever
she wanted there.

Note in "Lesson" the inevitably mixed feelings one
might harbor with respect to so strong a mother as the
one in "Lesson." Again, a poet's lyrical mode allows her
to see her world, as it were, in the round.

Amazingly, this author keeps getting better. If you
have not read her most recent collection, *Headwaters,* I
urge you to grab that one too. Magnificently inventive,
lyrical, and humane, this collection touches me as few if
any recent books of poetry have done.

These admiring reflections on my predecessor serve
well as prologue to similar reflections on my successor,
Chard de Niord, who, while a very different poet from
Ellen Bryant Voigt, also demonstrates in his poems the
characteristics I just catalogued. Below I'll quote a poem
from his 2011 collection *The Double Truth,* a poem that

by my reading—although I mean not to offer a commentary here—accords with the claims I've been making for lyric over my four years in the post that Mr. de Niord will shortly inherit.

But let me say beforehand that Vermont is lucky to have as its new poet laureate someone who is not only unusually gifted but also (a corollary that I wish were more consistent than in fact it is among artists) a very nice guy. I'll close my book by quoting a poem of Chard's.

Instructions for Telling the Truth

Begin by removing one article of clothing at a time,
 slowly,
until nothing's left to take off and no one's watching.
Patience, patience, as your words replace your garments
and suddenly you're standing alone in the square
like a flower that speaks in silence with so many
 tongues.

About the Author

⁓

SYDNEY LEA was Vermont's 2011-2015 Poet Laureate. He has published numerous books in multiple genres, among them *Pursuit of a Wound*, a finalist for the 2001 Pulitzer Prize for poetry. He is the founder of *New England Review* and has been awarded Rockefeller, Fulbright, and Guggenheim fellowships. He has taught at Dartmouth, Yale, Wesleyan, Vermont, and Middlebury colleges, as well as at Switzerland's Franklin College and Budapest's National Hungarian University. His stories, poems, essays and criticism have appeared in *The New Yorker, The Atlantic, The New Republic, The New York Times, Sports Illustrated* and many other periodicals, as well as in more than fifty anthologies. His twentieth book, and his thirteenth collection of poems, *Here*, appeared from Four Way Books, NYC, in late 2019, and his mock-epic graphic poem, *The Exquisite Triumph of Wormboy*, in collaboration with former Vermont Cartoonist Laureate James Kochalka, was published in 2020. He lives in Newbury, Vermont, and he is active both in community literacy efforts and in environmental conservation.